SIMPLE LIGHTING TECHNIQUES

FOR PORTRAIT PHOTOGRAPHERS

BILL HURTER

AMHERST MEDIA, INC. ■ BUFFALO, NY

About the Author

Bill Hurter started out in photography in 1972 in Washington, DC, where he was a news photographer. He even covered the political scene—including the Watergate hearings. After graduating with a BA in literature from American University in 1972, he completed training at the Brooks Institute of Photography in 1975. Going on to work at *Petersen's PhotoGraphic* magazine, he held practically every job except art director. He has been the owner of his own creative agency, shot stock, and worked assignments (including a year or so with the L.A. Dodgers). He has been directly involved in photography for the last thirty years and has seen the revolution in technology. In 1988, Bill was awarded an honorary Masters of Science degree from the Brooks Institute. He has written more than a dozen instructional books for professional photographers and is currently the editor of *Rangefinder* magazine.

Front cover photograph by Claude Jodoin.
Back cover photograph by Tim Schooler.

Published by:
Amherst Media, Inc.
P.O. Box 586
Buffalo, N.Y. 14226
Fax: 716-874-4508
www.AmherstMedia.com

Publisher: Craig Alesse
Senior Editor/Production Manager: Michelle Perkins
Assistant Editor: Barbara A. Lynch-Johnt
Editorial Assistance: Carey Maines, John S. Loder

ISBN-13: 978-1-58428-223-4
Library of Congress Control Number: 2007942657

Printed in Korea.
10 9 8 7 6 5 4 3 2 1

Table of Contents

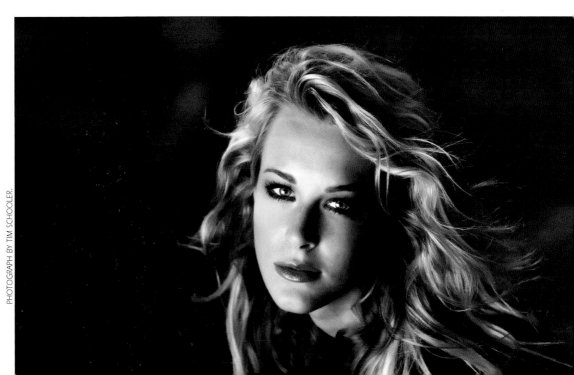

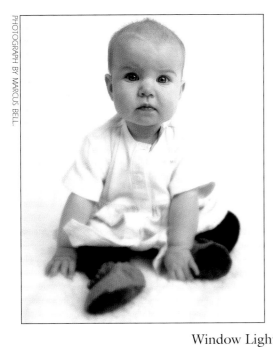

PHOTOGRAPH BY MARCUS BELL.

PHOTOGRAPH BY LARRY PETERS.

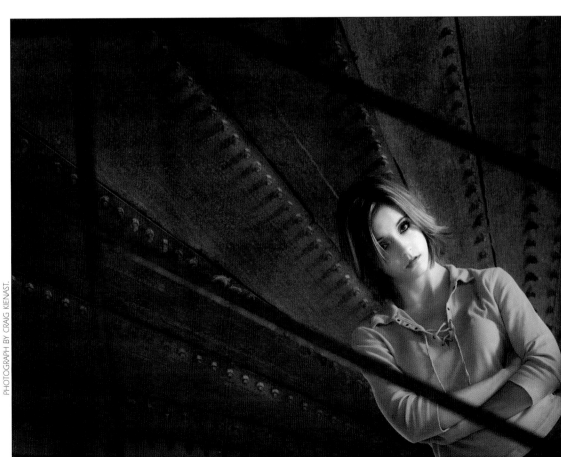

Introduction

In the foreword to Richard Avedon's photographic classic *In the American West* (Harry N. Abrams, 1985), the great American portraitist says, "I've worked out of a series of no*s*. No to exquisite light, no to apparent compositions, no to the seduction of poses or narrative. And all these no*s* force me to the yes. I have a white background. I have the person I'm interested in and the thing that happens between us."

Almost more than any other factors, the vast body of work that Richard Avedon produced—and the simplicity of that statement—changed the face of modern-day portraiture. Avedon also introduced influences from the world of fashion and the editorial splendor of the great picture magazines into modern-day portraiture. As a result, modern portrait photography has become a simpler, friendlier, more accessible art form than the structured, formalized portraiture popularized by late-nineteenth century classical portraitists like John Singer Sargent. That portraiture demanded rigorously formal posing, based on ideas passed down by the ancient Greeks, and a system of conventions that resulted in stilted and—by today's standards—somewhat lifeless renderings.

Avedon, and those that followed, changed the way we think portraiture should work. It should be accessible. It should provide a gateway to character. It doesn't have to be pretty, as long as it is insightful and revealing. Most importantly for this discussion, Avedon's work also broke down almost all of the established rules. His subjects appeared with their shoulders square to the camera, in direct violation of all posing "rules." His light was flat and often not flattering, but it provided a fleeting, if often frightening, glimpse into the souls of his subjects, revealing not only their individual natures but the broader views and often darker sides of human nature.

RIGHT—Images with an urban look are popular with Tim Schooler's senior-portrait clients. In this case, the young woman's outfit inspired Tim to select an offbeat location for her portraits—an abandoned building that had its face blown off by Hurricane Rita in 2005. The destruction revealed a great shooting area, covered with colorful graffiti. To camera right, the building was totally open to the street, and the opening created a soft directional main-light source. Tim just added a little reflected fill to complete the image.

But, of course, this is not a book about fine-art portraiture, it is about commercially viable techniques. Yet even in this genre, the impact of artists like Richard Avedon has been felt; as a result, the techniques photographers use today, simpler and more natural than ever before, are completely different than they were even twenty-five years ago.

Simplicity is Natural

Most accomplished photographers will agree that lighting should never call attention to itself. Even if you are adept at using five lights in harmony, the visual impact of the

subject must still be more powerful than the visual impact of the lighting. Very often, an elegant photograph can actually be made with a single light and reflector and nothing more.

The fact that such simplicity is an underlying principle of successful lighting is hardly surprising. In nature (on this planet, at least) life revolves around a single sun, so there is only one true light source. As a result, we are subconsciously troubled by the disparity we perceive when multiple shadows, created by different light sources, contradict each other. If, on the other hand, there is a single unifying direction to the light, with a single set of corresponding shadows, we are satisfied that it appears normal.

See the Light

This book is all about light, but not about how to use five, six, or seven lights in the studio. Instead, it is about how to create simplified lighting that can lead to more spontaneous, character-evoking portraits.

The goal of this book is to provide a broad background of information on which to base such an understanding of light and lighting—knowledge you can build into your everyday shooting routine. Through the images and observations of the great photographers featured, you will learn a wealth of uncomplicated lighting applications that will expand your photographic abilities and, hopefully, persuade you to become a serious student of light, learning from its many nuances and almost infinite variety.

Don Blair, a noted portrait photographer and teacher, once said that the photographer who has trained himself to "see light" could look at any photograph and discern precisely how it was lit. Learning to see light, understanding how it works, and appreciating good lighting are at the root of all great photography—but simply appreciating good light is not enough. Truly mastering the technical aspects of lighting is a cultivated discipline that takes years of vigilant observation. And like all complex skills, the more one knows, the more one discovers how much there remains yet to be learned.

Blair, who lived in Utah, loved to take long uninterrupted walks in the woods, where he would study the light as it passed through the overhead canopy, or at the edge of a

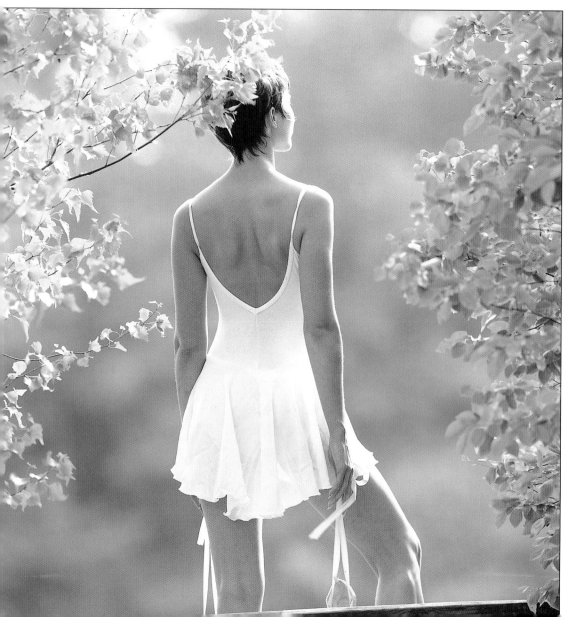

A portrait without a face? Does it reveal character and is it exquisitely lighted? Absolutely. This is a portrait by Tony Corbell, who learned much of his lighting technique from Don Blair. This image was made at the edge of a clearing where the light was perfect. The image is backlit, rimming the ballerina in a crisp highlight. The fill light came from a small reflector behind the ballerina.

A brief moment in this fluid scene became a memorable photograph as a result of Joe Buissink's incredible timing and the learned skill of seeing light. The color balance is uncorrected, there is subject movement and a little camera movement due to the very low light level. Yet this portrait is pure style and elegance captured as though from a movie unfolding before Joe's viewfinder.

clearing. He marveled at how light would change based on your point of view; move a few feet in either direction, and the light is different—sometimes remarkably different. These walks in the woods were perceptual odysseys he enjoyed frequently and they taught him the nuances of nature's light, and consequently the nature of light itself.

In an interview with noted photography writer Peter Skinner for *Rangefinder* magazine, Don once observed, "Notice the leaves and you will see variations in the color of the new, bright ones in contrast to the older leaves: variations you can enhance by camera position relative to light direction." More than the light's quality or quantity, how a photographer handles these infinite variations is a crucial factor in determining whether, in the end, a photograph succeeds or fails.

Another light aficionado, Joe Buissink is someone that professional athletes would call "a student of the game." He never stops learning and reinterpreting what he sees with his own two eyes. In a recent blog entry, he wrote, "I won't deny that I'm obsessed with light—even as I was walking around in the airport a few minutes ago, I found myself looking for interesting images—all created from overhead light, window light even the reflection off the floor. Your senses in an airport environment are bombarded with fluorescent, incandescent, and natural light. I may not have had my camera in hand, but I shot 'neuro-chromes' in my head and could even imagine the click of the shutter. And, it was all about looking at the way the light hit the subjects."

When Joe is working with available light, he's learned to make the most of what he has instead of replacing it with what he brings. If all he's got is an overhead fixture, for example, he'll use a reflector to put some light back into the bride's face and get rid of the shadows under her eyes. "I've used a pillow to pop some light back into the bride's face. I've used drapes, sheets, comforters, pillows, and even my black jacket for subtractive lighting. I've even used the drapes in a room and had my assistant pull the material behind the bride and bring it in on her other side. The light comes in on her opposite side from the window, hits the curtain, and reflects back into her face. Using a shallow depth of field and focusing on the bride's eyes, I'll never see the drapery behind her, but I will have the impact of beautiful soft wraparound light." The long and short of it? A creative approach is more important than an overstuffed equipment bag.

Joe suggests the following exercise. "Take your camera and get a couple of friends or hire a couple of models for the day. Go to some place typical of lousy lighting—like a shopping mall. Then, use your digital camera as a teaching tool and simply practice

BOTTOM LEFT—This is an oddly wonderful portrait made with a shoot-through umbrella, a reflector and a wide-angle lens (note the curious perspective). This is a great example of the new style of portraiture, where revealing layers of a person's life and personality—even that of a baby—is more important than the form of the portrait. Photograph by Marcus Bell. **BOTTOM RIGHT**—Today's portraiture features longer lenses, wide-open taking apertures, and narrow bands of focus, such as seen in this portrait by Tero Sade. The image was made with a Canon EOS 20D and 200mm lens at $^{1}/_{500}$ second at f/2.8 at ISO 400 by reflected daylight. An attractive vignette was applied in Photoshop to keep the viewer's eye within the print borders.

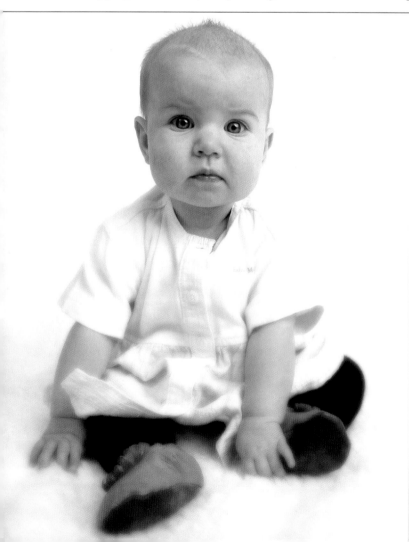

Minutes after finishing a workout, this boxer was photographed by Ken Sklute by the mixed daylight and incandescent light of the gym. An image like this might not have been well received in generations past, but it is quite popular now because of people's totally changed attitudes toward portraiture. Notice the realism of the scene—the electrical wall outlets, the bare light bulb, the drab and dingy paint of a downtown gym. The photo was made with a Canon 1Ds Mark III with a 105mm lens. The exposure was ⅛ second at f/3.5 at ISO 400.

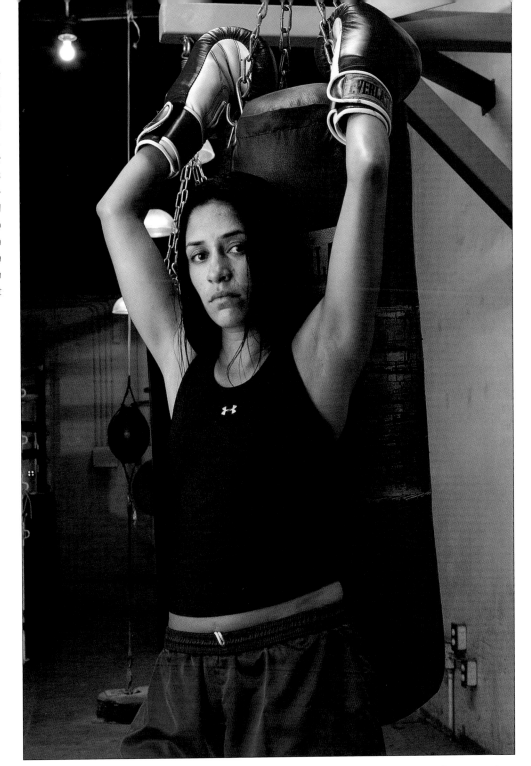

seeing the light. Take along a pillow case or a bed sheet to improvise and get used to working under the stress of not having the exact tools on your wish list with you at all times. Vary the exposures. Photograph using different meter settings and get to know your equipment better than the manufacturer who built it!"

Joe also suggests knowing when it's time for a change. "There are some times when it makes sense to simply move your subject into a little better light," he says. "You've got a responsibility to create the very best images possible. If moving your subject a few feet is going to create a more powerful photograph, then why wouldn't you want to make the change?"

Anyone who has ever seen Joe Buissink work is amazed at how fast his brain and eyes work. To paraphrase the great UCLA coach, John Wooden, he's quick but he does not hurry. He exploits every nuance of the natural ingredients of a scene and the emotion of his subjects with a calm brevity. His incredible ability to see and control light, like that of Don Blair and many before him, has been honed through experience. It is an acquired skill—and one that takes good powers of observation to foster and a desire to improve in order to perfect.

Why Are Things Different Now?

So much has changed in the way we record our special moments today as compared to fifty or even twenty years ago.

Film used to be slow and required a lot of light to adequately capture even a merely satisfactory portrait. With digital technology, however, existing-light portraiture has be-

come fun and easy. You can now change film speeds on the fly, allowing you to move seamlessly from bright sunlight, to shade, to subdued indoor light.

With digital photography, mixed light situations have also become easier to deal with. Location lighting, even room lighting, can be mixed with daylight in an almost carefree manner and the results will still be fantastic. In the days of film, your color film was balanced for either daylight or tungsten lighting. If an odd type of lighting was used or if you needed to work in a mixed-lighting situation, you would have to filter the scene by gelling the lights or placing a CC (color correction) filter over the lens. This was a nightmare of uncertainty. The photographer had to quickly have the film processed and eagerly await the results, which could be tempered by a dozen factors outside the photographer's influence. Now you can check the color balance immediately on the camera's LCD, adjust "on the fly," and ensure the expected outcome in each of your exposures.

LEFT—This image is actually two separate shots composited together in Photoshop. Reed Young shot it in Minneapolis when it was about 2°F. outside. According to Reed, "I actually had a model present, but when I turned the modeling lights on they exploded because of the shock of heat to the glass. I learned the hard way on this one. So, I took the model into the studio and did my best to simulate the street lighting. I placed a strobe about 12 feet in the air to camera right and that was it. I carefully selected him and placed him on the intended background using Photoshop. This is something I usually avoid, but I think it's less noticeable if you never knew the story."

Changing Mores

With changing styles and attitudes, portraiture has also become less rigid. People don't want sternly posed images in which they look like someone else. Instead, they want to be recorded as animated versions of themselves. They want to be shown as fun and spontaneous—as people who are having a good time and living life to its fullest.

The influence of fashion photography, with its heavily diffused lighting and untraditional posing, is one big reason for this shift. Another is the move by professional photographers to the smaller-format digital camera, with its instantaneous nature and its formidable bag of creative tricks. The modern DSLR gives photographers a level of flexibility that lends itself to shooting lots of images in many variations, including more spontaneous poses. Also, the advent of TTL-metered electronic flash has made the modern-day portrait something that can be made anywhere, not just in a studio.

As a result, the studio has been at least partially replaced by real life; the lights, stands, and backdrops have been supplanted by real-world props and events. However, this does not mean that the disciplines of the studio have faded into oblivion—they've just moved. Today, it is not uncommon for world-class photographers, like Bruce Dorn or Fuzzy Duenkel, to travel to destinations loaded with portable gear that allows them to bring back incredible images from wherever they end up, regardless of the conditions.

Despite these technological advances, though, many of the techniques of the old-time portraitists have survived and are useful to today's photographers. The rudiments of lighting and composition are timeless and date back to the beginnings of art. This book attempts to combine some of the time-tested disciplines with the more contemporary methods in such a way that they will be useful to the modern-day photographer. The emphasis will be on techniques rather than on sophisticated studio equipment. After all, if a portrait can be made with two lights just as simply as with five lights, why not use the simpler setup?

1. How Light Behaves

This chapter is an introduction to light and its behavior. While it is not necessary to understand light like a physicist would understand light, knowing that light is energy and how that energy works is both significant and useful when applying light photographically.

What is Light?

Light is energy that travels in waves, which are traveling energy. Waves usually move through a medium, like water. Imagine the waves in a swimming pool after someone has jumped in. Is it the water that is moving or something else? Actually, the water in the pool stays pretty much stationary. Instead, it is the energy, the wave, caused by the person jumping into the pool that is moving.

Light waves are different than water waves, however, in that they don't require a medium through which to travel. In fact, light travels most efficiently in a vacuum—other elements like air and water actually slow light down. Light travels so fast in a vacuum—186,000 miles per second—that it is the fastest known phenomenon in the universe!

Light waves consist of both electric and magnetic fields of energy, known as electromagnetic fields. Like all forms of electromagnetic energy, the size of a light wave is measured in wavelengths—the distance between two corresponding points on successive waves. The visible spectrum is only a tiny section of the full range of the electromagnetic spectrum, which also includes radio, microwaves, infrared, ultraviolet, X-rays, and gamma rays—types of waves that are differentiated by their unique wavelengths. The wavelengths of visible light range from 400 to 700 nanometers (one millionth of a millimeter).

"One of the characteristics of light that is important to photography has to do with reflected light waves."

The Behavior of Light

Reflection. One of the characteristics of light that is important to photography has to do with reflected light waves. When light hits a reflective surface at an angle (imagine

sunlight hitting a mirror), the results are totally predictable. The reflected wave will always come off the flat, reflective surface at the opposite angle at which the incoming wave of light struck the surface. In simple terms, the law can be restated as this: the angle of incidence is equal to the angle of reflection. Whether you are trying to eliminate the white glare of wet streets as seen through the viewfinder or to minimize a hot spot on the forehead of your bride, this simple rule will keep you pointed toward the source of the problem.

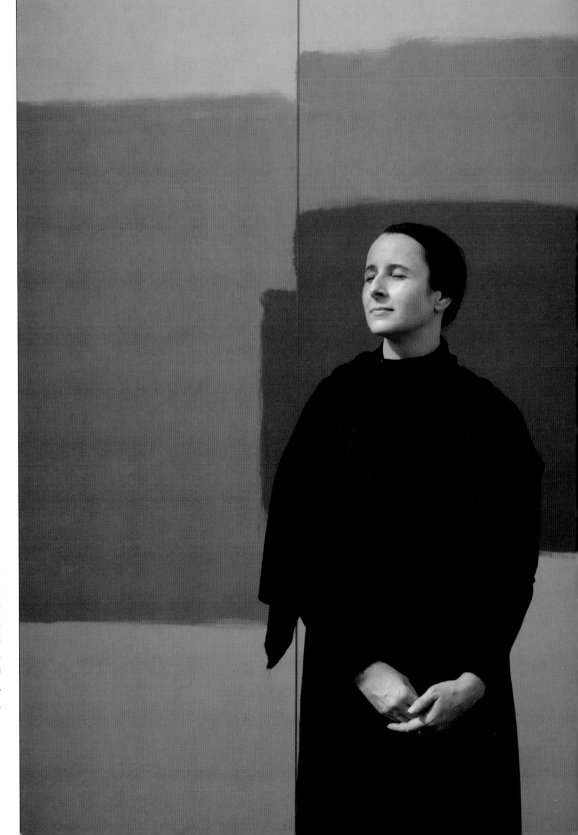

This amazing portrait is lit in a formal way, with a loop lighting pattern created by the sun streaming in through a skylight. The lighting is austere, as is the subject matter—an artist in front of her work. The photograph is by Johannes Van Kan of FlaxStudio in New Zealand. The color balance and tint were drastically altered in RAW file processing.

Multiple windows lit this pleasant room, creating a wall of diffused light that seems to have little or no direction. Photograph by Giorgio Karayiannis.

This rule also has applications in product and commercial photography. For example, when lighting a highly reflective object like silverware, knowing that the angle of incidence equals the angle of reflection tells you that direct illumination will not be the best solution. Instead, you should try to light the surface that will be reflected back onto the shiny object's surface.

Scattering. Scattering is reflection, but off a rough surface. Basically, because the surface is uneven, incoming light waves get reflected at many different angles. When a photographer uses a reflector, it is essentially to distort the light in this way, reflecting it unevenly (or, put another way, so that it diffuses the light).

Translucent surfaces, such as the rip-stop nylon used in photographic umbrellas and softboxes, transmit some of the light and scatter some of it. This is why these diffusion-lighting devices are always less intense than raw, undiffused light. Some of the energy of the light waves is discarded by scattering, and the waves that are transmitted strike the subject at many different angles, which is the reason the light is seen as diffused.

Refraction. When light waves move from one medium to another, they may change both speed and direction. Moving from air to glass (to a denser medium), for example, causes light to slow down. Light waves that strike the glass at an angle will also change direction, otherwise known as refraction. Knowing the degree to which certain glass el-

ements will bend light (known as the refractive index) allows optical engineers to design extremely high-quality lenses, capable of focusing a high-resolution image onto a flat plane (the film or image sensor). In such complicated formulas, now almost exclusively designed by computers, the air surfaces between glass elements are just as important to the optical formula of the lens as the glass surfaces and their shapes.

In lighting devices, refraction is used with spotlights and spots with Fresnel lenses. These lenses, placed close to the light source, gather and focus the light into a condensed beam that is more intense and useful over a greater distance than an unfocused light of the same intensity. Spotlights are theatrical in nature, allowing the players on stage to be lit from above or the side by intense but distant lights, but they also have many applications in contemporary photography.

Absorption. When light is neither reflected nor transmitted through a medium, it is absorbed. Absorption usually results in the production of heat but not light. Black flock or velvet backgrounds are often used to create dense black backgrounds because they absorb all of the light striking their surfaces.

The Intensity of Light

Another characteristic of light has to do with intensity. Illumination from a light source declines considerably over distance, which is to say that the light grows weaker as the distance increases between the light source and the subject. Light from sources other than the sun (see below) falls off predictably in its intensity.

Put precisely, the Inverse Square Law states that the reduction or increase in illumination on a subject is inversely proportionate to the square of the change in distance from the point source of light to the subject. For example, if you double the distance from the light source to the subject, then the illumination is reduced to one quarter of its original intensity. Conversely, if you halve the distance, the light intensity doubles.

This law holds true because, at a greater distance, the same amount of energy is spread over a larger area. Thus any one area will receive less light.

"While the Inverse Square Law is true for all light sources, it is not particularly relevant for the sun."

It should be noted that while the Inverse Square Law is true for all light sources, it is not particularly relevant for the sun. This is because of the minuteness, here on earth, of any potential change in our relative distance from the sun. For all practical purposes, then, the sun is infinitely bright; it is the only light source that does not fall off appreciably as the distance from the light source increases. Of course, this is not the case with window light, where the light-emitting window, rather than the sun, is the light source. As all photographers who have ever had to work with window light know, light does fall off the farther you get from the window. For more on window light, see chapter 2.

Light Quality

Because portraiture is an "idealizing" art form in which the photographer normally aims to minimize the subject's flaws, the quality of the light is all-important to the final rendering.

Light is described as being either specular (creating intense highlights and dark shadows) or diffuse (creating gentle highlights and soft shadows). Which type of light a given source will produce depends on its size and its distance from the subject.

Specular light is created when the light rays incident on the subject are parallel. When this occurs, the highlights on the subject are small and intense and the shadows—both those on the subject and those cast by the subject—are deep and have strong lines of demarcation between the highlight and the shadow (see Reflected Light Values on page 21). This makes it good for revealing texture or creating images with a dramatic effect. Specular light is produced by using smaller light sources, like bare bulbs or lights that employ lenses or polished reflectors to focus the rays. These produce crisp shadows with sharper transitions from highlight to shadow across the subject.

Diffuse light occurs when the light rays incident on the subject are scattered (i.e., not parallel). When this occurs, the light reaches around edges of the subject, allowing it to illuminate the shadows and spread out into the highlights. This softens the overall look of the lighting and opens up shadow areas, decreasing the darkness of the shadows and obscuring any line of demarcation between the highlight and shadow regions. Diffuse light is produced using large light source, like softboxes and umbrellas (see chapter 2)

This is what extremely diffused light looks like. Photographer Beth Forester used a Photogenic Powerlight with a 3x4-foot Larson Soffbox as the key light and a Larson 3x5-foot reflector for fill.

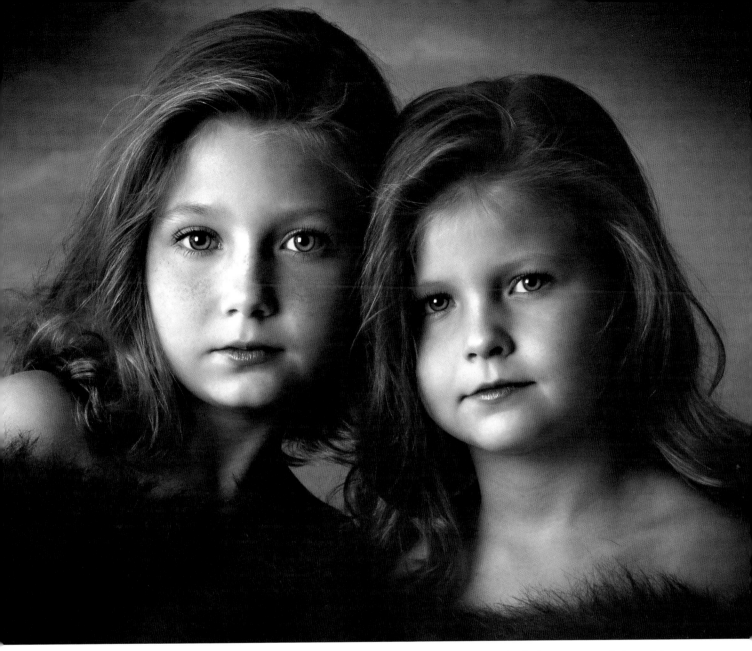

and/or by placing a light-scattering medium between the light source and the subject. Light can also be diffused naturally due to atmospheric conditions. Larger light sources produce softer shadows with a more even gradation from highlight to shadow—perfect for showing smoothness or softness. As a result, they tend to be more forgiving and easier to use than specular sources. The disadvantage to using large light sources, however, is that they reveal less texture.

When selecting a light source, it is important to consider its effective size. This is determined both by the physical size of the source itself and its distance to the subject. Even with large light sources, the light will become more specular as the source is moved away from the subject.

Reflected Light Values

There are three distinct values of reflected light: specular highlights, diffused highlights, and shadow values (sometimes referred to collectively as lighting contrast). Specular highlights are areas of pure paper-base white that have no image detail. Specular high-

lights act like mirrors of the light source and exist within diffused highlight areas, adding brilliance and depth to the highlight. Diffused highlight values are those bright areas that do contain image detail. Shadow values are areas that are not illuminated or are only partially illuminated.

Small, focused light sources have higher specular quality because the light is concentrated in a small area. Larger light sources like softboxes and umbrellas have higher diffused highlight values because the light is distributed over a larger area and is scattered. See chapter 2 for more on different light sources and the effects they produce.

The shadow-transfer edge, the region where the diffused highlight meets the shadow value, also differs between these two types of light sources. Depending on the size of the light, the distance of the light from the subject, and the level of ambient or fill light (see chapter 3), the transition can be gradual or dramatic. With a small light, the transfer edge tends to be more abrupt (depending, again, on the level of fill light). With larger light sources, the transfer edge is typically more gradual.

Brian Shindle created this beautiful father and son portrait with a single light source, a very large softbox used close to his subjects at about 30 degrees to the left of the camera. Notice the transfer edge, from highlight to shadow—the transition is very gradual, which is one of the goals of using diffused lighting. The exposure is perfect as Brian maintains textured detail in the black clothing and specular detail in the highlights.

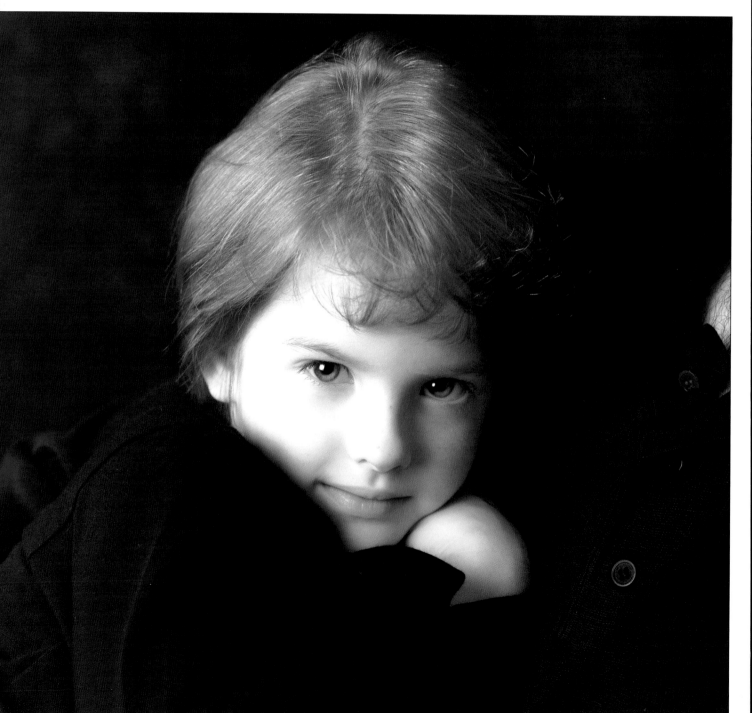

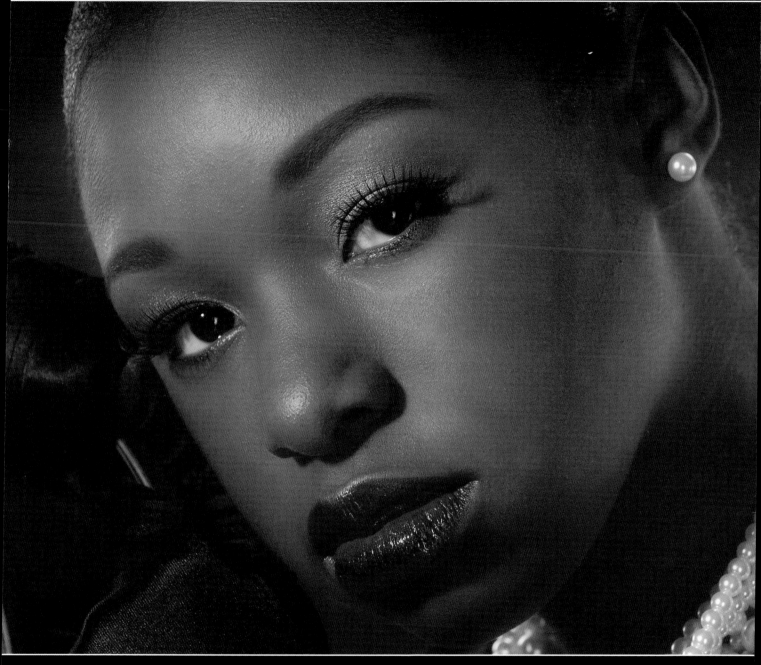

Fran Reisner created this beautifully lit portrait using an undiffused main light positioned above the model's head on an axis with her nose. Various diffused and undiffused light sources were used both for fill and for accent (see diagram). Notice that since the main light is undiffused and comes from a skimming angle, it produces texture and great highlight brilliance (specular highlights within the diffuse highlights). Often these details are a function of feathering the main light until the skin "pops" with specularity.

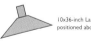

10x36-inch Larson softbox
positioned above subject height

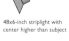

48x6-inch striplight with
center higher than subject

subject

key light (Bron head
in silver reflector above and
to the left of the subject)

camera

fill light (4x6-foot Larson softbox)

The Color of Light

When we look at a visible light source, it appears to be colorless or white. However, it is actually a mixture of colors that the eye *perceives* as white. We know this because if you shine "white" light through a prism, you get a rainbow of colors, which are the individual components of the visible spectrum.

Yet, while the human eye perceives most light as white, few light sources are actually neutral in their color. Most have some some color cast, be it the yellow tint of household incandescent light bulbs, or the green color cast of many fluorescents. The color of light is measured in degrees Kelvin (K) and, therefore, known as the color temperature. The Kelvin scale, like the Fahrenheit and Centigrade scales, is used to measure temperature. It was devised in the 1800s by a British physicist named William Kelvin, who heated a dense block of carbon (also known as a "black body" radiator) until it began to emit light. As more heat was applied, it glowed yellow, and then white, and finally blue. The temperature at which a particular color of light was emitted is now called its color temperature. As you can see in the chart below, natural and artificial light sources have many different color temperatures.

Daylight Color Temperatures

Clear blue sky	8000–27,000K
Misty daylight	7200–8500K
Overcast	6500–7200K
Direct sun, blue sky	5700–6500K
Midday sun (9:00AM–3:00PM)	5400–5700K
Sun at noon	5000–5400K
Early morning or late afternoon	4900-5600K
Sunrise or sunset	2000–3000K

Artificial Light Color Temperatures

Fluorescent, daylight-balanced	6500K
Electronic flash	6200–6800K
Fluorescent, cool white	4300K
Photoflood	3400K
Tungsten-halogen	3200K
Fluorescent, warm white	3000K
General-purpose lamps (200–500W)	2900K
Household lamps (40–150W)	2500–2900K
Candle flame	2000K

Achieving Color Balance. It is important for photographers to understand color temperature, because achieving the desired color balance in an image often requires compensating for the color of the light source. This is most commonly accomplished through film selection, filtration, or white-balance selection.

FACING PAGE—Light formed by a laser is monochromatic, containing one specific wavelength of light (color). The light released is coherent and extremely directional. It has a very tight beam pattern and is strong and concentrated. Lasers use mirrors to focus the beam of light, which stays intact over great distances. Australian Jerry Ghionis was skillful enough to talk his way into using a very elaborate laser special-effects system to photograph twelve brides in twelve different high-fashion dresses. He persuaded an Australian fashion magazine to give the laser company credit throughout the layout, otherwise the rental of such equipment would have been in excess of $4000 (Australian) per hour. Jerry selected a venue with stage lighting and a smoke machine was used to amplify the intensity of the laser beams. The images were captured with a Canon 20D with an 85mm f/1.8 lens. He used the camera on a tripod, shooting at 1/15 second f/4–5.6. The only Photoshop that was used was color correction, selective Gaussian blur, and skin retouching.

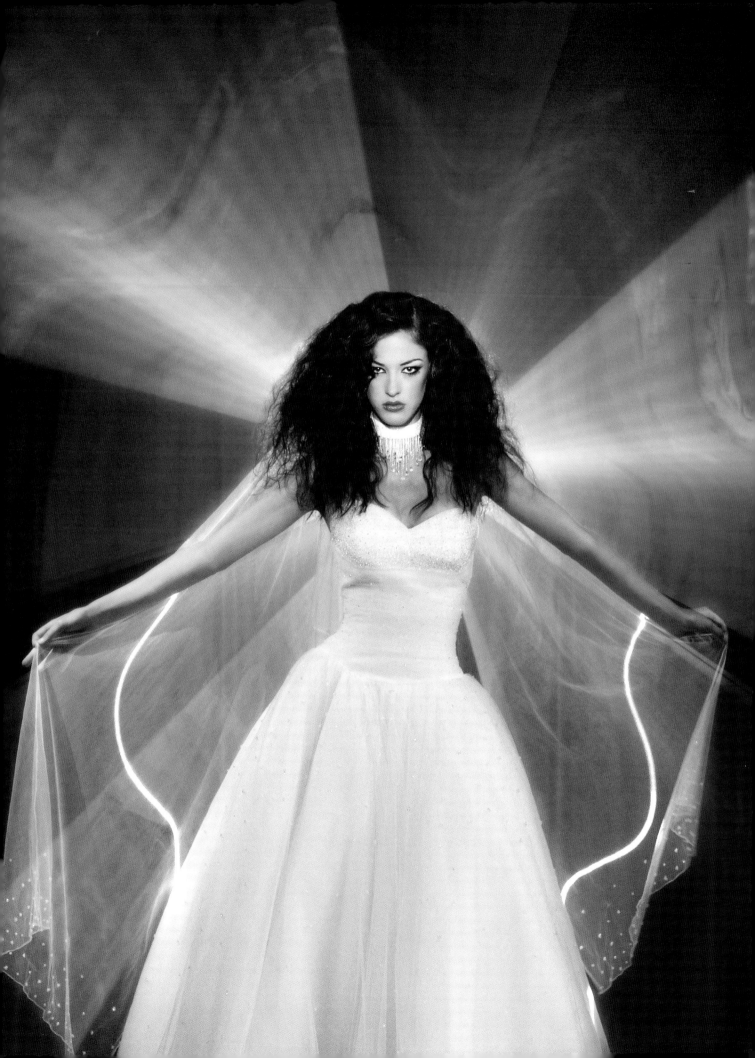

Daylight films are balanced to render colors accurately when photographing under light with a color temperature of 5500K. Therefore, they produce the most accurate color during the middle of the day (9:00AM–3:00PM). Earlier and later than these hours, the color temperature dips, producing a warmer-toned image in the yellow to red range. Tungsten films, on the other hand, are balanced for a color temperature of 3200K, considerably warmer than daylight. In the film world, color balance can also be accomplished using color-compensating filters when recording an image under an off-balance light source.

"When precision color balance is critical, a color-temperature meter can be used to get an exact reading."

In the digital world, things are much simpler; you merely adjust the white-balance setting of the camera to match the color temperature of the light. Digital SLRs have a variety of white-balance presets, such as daylight, incandescent, and fluorescent. Custom white-balance settings can also be created by taking a reading off a white card illuminated by the light source in question. When precision color balance is critical, a color-temperature meter can be used to get an exact reading of the light's color temperature in Kelvin degrees. That figure can then be dialed into the white-balance system of many cameras.

Digital portraiture can be conceived and executed in any color balance the maker chooses. In this wonderful portrait of father and child, this image by Jo Gram of FlaxStudio in New Zealand, was made in RAW file mode with a Canon EOS 1Ds Mark II with a custom white balance where the tint was drastically altered in RAW file processing. In fact, almost nothing about the image was recorded normally, from exposure, to vignetting, to tint.

2. Light Sources and Equipment

Having explored the behavior of light, we will now move on to look at the many options photographers have for producing light. From studio strobes, to portable flash, to handheld video lights—the choices are almost limitless. Also in abundance are the options for modifying whatever light source you select, ensuring that you can achieve just the look you want in your images.

Metering the Light

Exposure is critical to producing fine portraits, so it is essential to meter the scene properly. However, using the in-camera light meter may not always give you consistent and accurate results.

Reflected Light Meter. In-camera meters measure reflected light and are designed to suggest an exposure setting that will render subject tones at a value of 18-percent gray. This is rather dark even for a well-suntanned or dark-skinned individual. So, when using the in-camera meter, you should meter off an 18-percent gray card held in front of the subject—one that is large enough to fill most of the frame. (If using a handheld reflected-light meter, do the same thing; take a reading from an 18-percent gray card.)

"From studio strobes, to portable flash, to handheld video lights—the choices are almost limitless."

Spotmeter. One type of professional meter that yields exacting results is the spot meter, which has a very narrow field of view—usually less than 5 degrees. Spot meters are reflected-light meters and for best results should be used with an 18-percent gray card, which will yield the proper exposure settings if held in precisely the same light that will expose your subject. If you wish to check lighting ratios (see page 64), hold the gray card facing the key-light source and take a reading on that axis. Do the same for the fill light, holding the card on axis and metering on that same axis. Make sure there is no glare on the card from any of the other lights when taking a reading.

Incident Light Meter. A better type of meter for portraiture is the handheld incident light meter. This does not measure the reflectance of the subject; instead, it measures the amount of light falling on the scene. To use this type of meter, simply stand

where you want your subject to be, point the hemisphere of the meter directly at the camera lens, and take a reading. Be sure that the meter is held in exactly the same light that your subject will be in. This type of meter yields extremely consistent results and is less likely to be influenced by highly reflective or light-absorbing surfaces. (A good rule of thumb when setting your lights is to point the meter at the light source if only one light source is being measured; if multiple lights are being metered, point the dome of the meter at the lens.)

Flashmeter. A handheld incident flashmeter is useful for determining lighting ratios (see page 64)—and crucial when mixing flash and daylight. Flashmeters are also invaluable when using multiple strobes and when trying to determine the overall evenness of lighting in a large-size room. Flashmeters are ambient incident-light meters, meaning that they measure the light falling on them and not light reflected from a source or object, as the in-camera meter does.

If any of the back lights (like hair lights or kickers) are shining on the meter's light-sensitive hemisphere, shield the meter from them, as they will adversely affect exposure. You are only interested in the intensity of the frontal lights when determining the correct exposure.

THE KEY LIGHT AND THE FILL LIGHT

Techniques for positioning lights for portraiture will be covered in detail in chapter 3. For the purpose of the ensuing discussion, however, it is important to be familiar with the function of the two principle lights: the key light and the fill light. The key light, sometimes called the main light, is the light that creates a pattern of highlight and shadow on the subject's face. The fill light is a weaker secondary source that serves only to lighten the shadows created by the key light; it should not cast its own set of shadows. (*Note:* This is because, as in nature where light comes from a single source [the sun], lighting in portraiture looks most natural when it appears to arise from a single source.)

Simple Light Modifiers

Whatever type of light source you decide to use—instantaneous or continuous, natural or man-made—there are a few common light modifiers you can used to sculpt the effects to your liking. (*Note:* Additional light modifiers made to be used specifically with studio light sources and in on-camera flash applications are included later in this chapter and should also be considered when using these sources.)

Portable LiteDiscs from Photoflex are flexible reflectors that fold up into a compact shape for transport. They come in a variety of surfaces and sizes and some are reversible. The shot above shows the effect of gold-foiled LiteDisc used close to the subject.

Fuzzy Duenkel is a master at manipulating daylight and converting it into soft and elegant studio-like lighting. Here he used a free-standing gold foil reflector to kick shade back onto his senior subject, creating a key light on her left side. You can see the catchlights in her eyes, which reveals the shape of the reflector.

Reflectors. A reflector is any surface that is used to bounce light onto the shadow areas of a subject. A wide variety of reflectors are available commercially, including the kind that are collapsible and store in a small pouch. The surface of reflectors can be white, translucent, silver foil, black (for subtractive lighting effects; see page 30), or gold foil. The silver- and gold-foil surfaces provide more light than matte white or translucent surfaces. Gold-surfaced reflectors are also ideal for shade, where a warm-tone fill light is desirable. Mirrors are also used to bounce light. These reflect a high percentage of the light that strikes them, so they can be used outdoors to channel backlight into a key light.

When using a reflector to produce fill light, it should be placed slightly forward of the subject's face, not directly beside the face. If the reflector is next to the face it will create a secondary light source (and second set of shadows) coming from the opposite direction of the key light. Properly positioned, the reflector picks up some of the key light and wraps it around onto the shadowed side of the face, opening up detail even in the deepest shadows.

Photographer Fuzzy Duenkel uses a homemade reflector he calls the "Fuzzyflector." It is basically two double-sided, 4x4-foot rigid reflectors hinged in the middle so that the unit will stand up by itself. The four separate sides each have a different finish, so they can be used to produce four different levels of reflectivity. A Mylar surface provides a very powerful reflector that can be aimed precisely to act as a key light in bright sun or an edge light from behind the subject. A spray-painted silver surface provides an efficient, color-balanced fill-in at close range. A white surface provides a softer fill and a black surface can be used for subtractive effects. Finally, a black matte surface can be used as a gobo (see page 30).

Because the reflector can be positioned in an L-shape to be freestanding, it can even be used as a gobo and reflector simultaneously. Another way the reflector can be used is to position it beneath the subject's chin so that it reflects light up into the subject's face. If using a tripod, one plane of the reflector can be rested on or taped to the tripod, or an assistant can be used to precisely position the reflector.

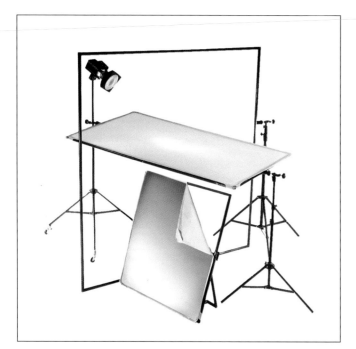

Scrims. Scrims are translucent diffusers. Light is directed through the material of the scrim to diffuse the light. In the movie business, huge scrims are suspended like sails on adjustable flats or frames and positioned between the sun (or a bank of lights) and the actors, diffusing the light over the entire area. A scrim works the same way a diffuser in a softbox works, scattering the light that shines through it.

Scrims can also be used in window frames for softening sunlight that enters the windows. Tucked inside the window frame, the scrim is invisible from the camera position.

Gobos. Sometimes, because of the nature of the lighting, it is difficult to keep unflattering light off of certain parts of the portrait. For instance, hands that receive too much light can gain excessive visual dominance in a photograph. When this happens, a good solution is to use a device called a gobo (or flag). This is a light blocking card, usually black, that can be attached to a boom-type light stand or held by an assistant. When placed in the path of a diffused light source, the light will wrap around the flag, creating a very subtle light-blocking effect. The less diffused the light source, the more pronounced the effect of the gobo will be.

In outdoor portraiture, these panels are often used to block overhead light when no natural obstruction exists. This minimizes the darkness under the eyes and, in effect, lowers the angle of the key light so that it is more of a sidelight. Gobos are also used to create a shadow when the source of the key light is too large, with no natural obstruction to one side or the other of the subject.

Studio Strobes

Strobe lighting is easy to work with because it is daylight-balanced, requires substantially less power to operate than continuous sources, and produces little or no heat.

Types of Systems. Studio strobes come in two types: monolights and power-pack kits. In either case, the strobes must be triggered by the camera to fire at the instant the shutter curtain is open. This is most simply accomplished with a sync cord that runs

from the camera's PC connection to one of the monolights or to the power pack, depending on the system you choose.

Monolights. Monolights are self-contained. These units contain light triggers to fire the strobe when they sense the light of another strobe, so they can be used very far apart and are ideal for location lighting or large rooms. Simply plug one or more into a household AC socket and you're ready to go.

Power-Pack Systems. Power-pack systems accept multiple strobe heads—up to four individual strobe heads can usually be plugged into a single moderately priced power pack. This type of system is most often used in studios, since you cannot move the lights more than about 25 feet from the power pack. Power-pack outlets are usually divided into two channels with variable settings, providing symmetrical or asymmetrical output distributed between one, two, three, or four flash heads.

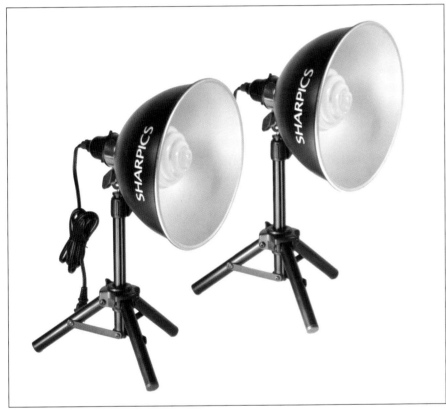

LEFT—The Sharpics Compact Studio Light Kit features two compact light stands, two 9-inch parabolic reflectors, and two 30W fluorescent 5000K studio lights all for a retail price of $129.95. This is the ideal inexpensive setup to purchase to teach yourself studio portrait lighting. **BOTTOM LEFT**—The Profoto D4 is a 4800Ws power pack that accepts four flash heads, which can be used asymmetrically or symmetrically. **BOTTOM CENTER**—The Broncolor Verso 2 is a 1200Ws microprocessor-controlled power pack with three lamp-base outlets, controlled over two channels. The Verso 2 is shown with Broncolor Mobil, a battery-operated power pack with two lamp-base outlets. The Mobil is also a 1200Ws unit, but lacks the Versos 2's asymmetrical power distribution, extended flash capacity, and super-quick recycling speed. Photograph by Bruce Dorn. **BOTTOM RIGHT**—The Profoto Pro-B2 is a battery-powered flash system designed for location photography. An internal 32-channel radio receiver is built in for remote operation.

What to Look For in a Studio Strobe System. Things to look for in a professional studio strobe system are:

Power. Strobe systems are rated in watt-seconds; the more watt-seconds, the more light output. Keep in mind that, when considering the total output rating of the power pack, you must divide the total watt-seconds (Ws) by the number of flash heads to be used.

According to Bruce Dorn, noted expert, "Consistency is the holy grail of flash photography and one of the desirable features you pay for in the higher-end product lines. Consistent output means smoother workflow and smoother workflow means more profitability."

Flash Duration. Look for short flash durations, ranging from $\frac{1}{800}$ to about $\frac{1}{12,000}$ second. The longer the flash duration, the less action-stopping ability the system has and the more likely it becomes that exposures may be influenced by existing light.

Recycle Times. Fast recycling times are desirable, ranging from 2 seconds down to less than $\frac{1}{4}$ second. The faster the recycling time, the faster you can make consecutive full-power exposures.

> "Some systems' color-temperature output will vary depending on the recycle rate, causing uneven color."

Digital guru, Claude Jodoin says, "When I use flash, I prefer the precision and repeatability of monolights with fast recycle times, such as the Alien Bees 400 and 800 units. Running those at an eighth or quarter power for apertures around f/5.6 (for zooms) lets the camera capture images as fast as a model can move. This eliminates underexposed images caused by slow-recycling flash heads. Since the noise maps of modern digital SLRs are not visible in a print between ISO 100–400, I usually increase that instead of flash power to maintain the highest shooting speed for a given lens aperture."

Modeling Lights. Proportional modeling lights are a necessity, so that each light can be made to closely resemble the output of the individual flash tube. Without accurate modeling lights, precise lighting effects are impossible.

Color Temperature. Consistent color-temperature output is a must-have feature. Some systems' color-temperature output will vary depending on the recycle rate, causing uneven exposures and color—and, therefore, color-correction problems. Variable color-temperature settings are available on some systems, which can be adjusted in 50K intervals for warmer or cooler output.

Fan-Cooled Generator. Power-pack systems have a tendency to overheat and will often require an internal fan to cool the electronics.

Multi-Voltage Capability. This feature allows the strobe system to be used in different countries with different power systems. Often, this is an automatic, self-seeking function that the photographer never even has to worry about.

FACING PAGE—According to Bruce Dorn, "For this late-afternoon sequence, I positioned our model, Eden, inside an organic structure of interwoven twigs and branches. I had to constantly chase the balance between ambient and flash-fill during this series." The main light was a Broncolor Unilite head equipped with a Broncolor parabolic reflector and grid. The light is feathered so that the cone of light skims just past the model's hair. According to Dorn, "This positioning feathers her blond tresses with a tiny taste of illumination while sending the bulk of the output directly into a Westcott Natural Muslin Reflector positioned for front-side bounce fill." Hazy afternoon sun contributed a diminishing key light as the big yellow orb sank toward the horizon. The image was created using a Canon EOS 5D with a 70–200mm f/2.8 IS zoom working between 110 and 145mm. The ISO setting was 320, and the exposure was $\frac{1}{125}$ second at f/4.

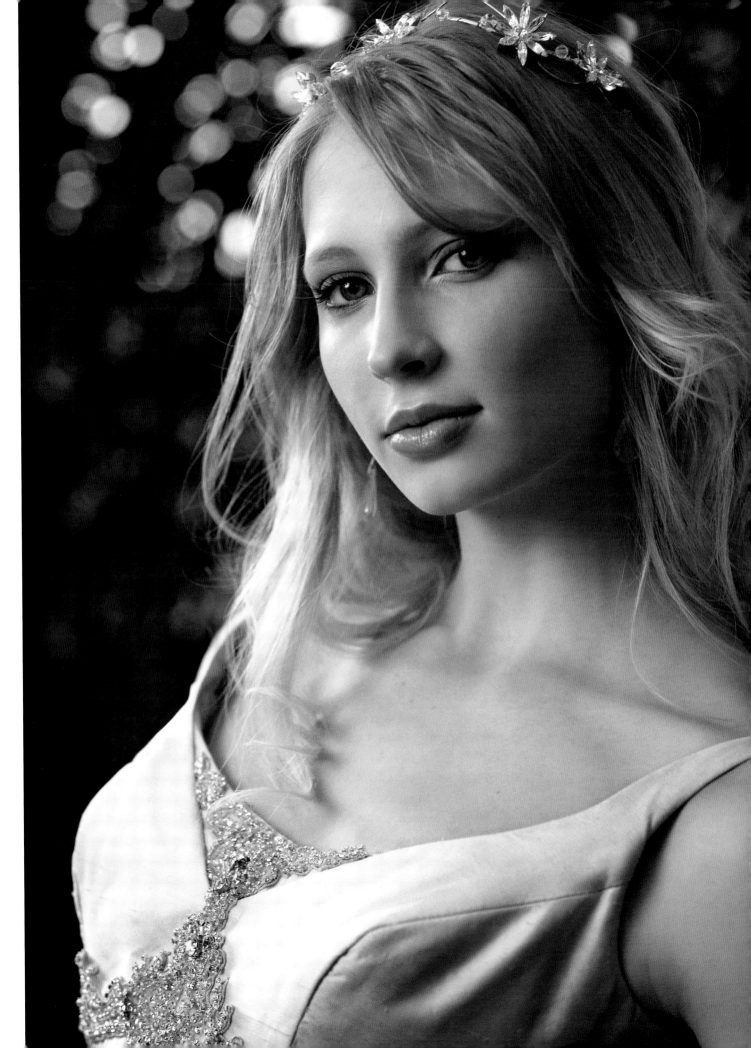

AN INEXPENSIVE ALTERNATIVE

The AlienBees B1600 is a powerful, self-contained studio flash unit that produces 640 true watt-seconds and 1600 effective watt-seconds of power. The power is independently adjustable over a stepless five f-stop range from full power down to $^1/_{32}$ power. This flash power is independently adjusted on the back control panel, with a slide fader that shows marked f-stop increments. The B1600 minimizes heat build-up, has increased overall durability, and offers shorter flash durations.

The recycle time to full power is just two seconds, and with precision voltage-regulated circuits supplying consistent output, the B1600 boasts WYSIWYG (what you see is what you get) accuracy. The modeling lamp can be set to full brightness, turned completely off, or set to track the power-output changes. The standard 100-watt modeling lamp may be used as a recycle indicator, turning itself off when the unit is recycling and coming back on to let you know when the unit is fully recycled and you are ready to shoot again.

The B1600 has a built-in slave tripper to allow wireless firing, so the unit will fire whenever it "sees" a flash from another source. It will also automatically dump the excess power, removing the excess charge when the flash power is adjusted from a higher to a lower setting. The list price of the B1600 as of this writing is $359.95.

Computer Control. Some of the recently introduced systems offer a computer interface so that settings can be changed from a laptop or PDA—an invaluable feature for remote applications.

Open-Flash Function. The open flash control fires the flash manually in the predetermined configuration. It is ideal for images where you want to leave the shutter open and fire multiple flash pops.

Heads and Accessories. The wider the range of flash heads, accessories and light modifiers available for any given system, the more useful the system.

Studio Strobe Accessories. Here are some variations in strobes and the accessories used to modify the quality and quantity of light output. Additional options for modifying light with scrims, gobos, and reflectors are found earlier in this chapter.

FACING PAGE—Claude Jodoin is a big proponent of Alien Bees B1600s because of the low cost, durability and consistency of the units. This image was made by adding a dark blue gel to the B1600 to tint a gray background. Frontal lighting consisted of a B1600 in a softbox and a reflector used close to the subject to lower the lighting ratio.

Barebulb. When the reflector is removed from the flash head, you have a barebulb light source. The light scatters in every direction—360 degrees. Removing the reflector has advantages if you have to place a light in a confined area. Some photographers use a barebulb flash as a background light for a portrait setting, positioning the light on a small floor stand directly behind the subject. Barebulb heads are also used inside softboxes, light boxes, and strip lights for the maximum light spray inside the diffusing device.

Parabolic Reflectors. Parabolic reflectors, also called "pans" because of their shape, mount to the perimeter of the light housing and serve to direct the light so it does not scatter in every direction from the bare bulb. In the old days (before strobes), everything was lit with polished-silver metal parabolics, because they provided the light intensity needed to capture an image on very slow film. This was obviously before strobes. The advantage of learning to light with parabolics is that you had to see and control light more efficiently than with diffused light sources, which are much more forgiving.

Parabolics create a light pattern that is bright in the center and gradually falls off in intensity toward the edges. The penumbra, the soft edge of the circular light pattern, is the area of primary concern to the portrait photographer. The center of the light pattern, the umbra, is hot and unforgiving and produces highlights without detail on the face. Feathering the light (adjusting the light to use the soft edge of the light pattern) will help achieve even illumination across the facial plane with a mix of soft and specular highlights.

Today, some pan reflectors are polished, while some use a brushed matte surface, which diffuses the beam of light. Some have facets that gather and focus the light. Photographers rarely use undiffused pan reflectors any more, but for beautiful specular light with a highly functional feathered edge, nothing beats the polished pan reflectors.

The smallest of the pan reflectors is usually the five-inch standard reflector, which is good for protecting the flash tube and modeling light from damage. It also makes the light more compact for traveling. The shorter, wide-angle pans spread light out in a wide pattern. This reflector is often used to focus the light onto the full surface of an

umbrella and to shoot into flats or scrims. The wider spread of light also makes this modifier ideal for bouncing light off ceilings and walls—it is controllable and efficient, with minimal light loss. The resulting bounced light is a very soft, and the quality can be easily controlled by changing the distance from the flash head to the reflector, wall, or ceiling.

Beauty Dish. The beauty dish is a wide pan reflector that is white on the inside. Beauty dishes tend to be large, about 22-inches in diameter. They also include an internal light shield above the filament, which makes it a bounce-only type of lighting.

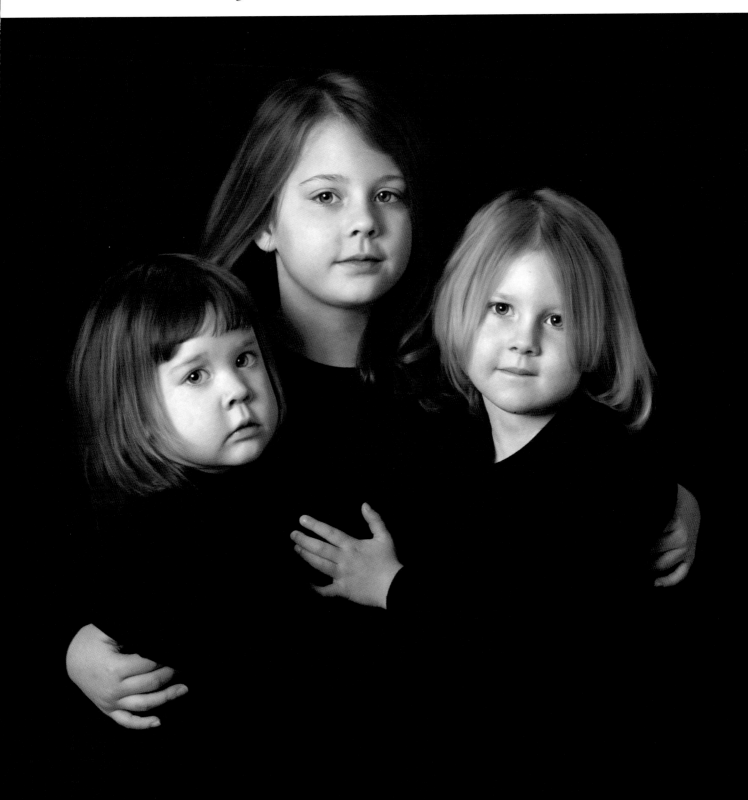

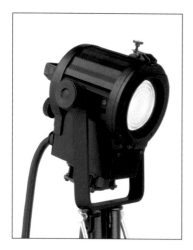 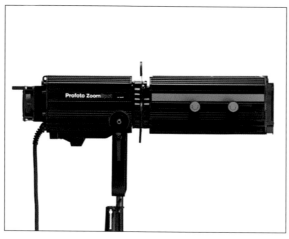 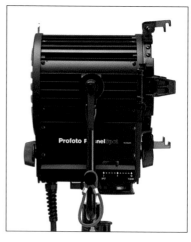

The raw light is forced into the surrounding white pan for a soft, but powerful portrait light. Beauty dishes produce round catchlights and good overall light contrast. They are usually used fairly close to the subject and feathered (they are ideal for feathering because, compared to softboxes, they are relatively small). Beauty dishes can be further diffused by covering the pan with an additional layer of diffusion material.

Barn Doors. These are black, metallic, adjustable flaps that can be opened or closed to control the width of the beam of the light. Barn doors ensure that you light only the parts of the scene you want lit. They also keep stray light off the camera lens, helping to prevent lens flare.

Diffusers. A diffuser is nothing more than frosted plastic or acetate in a frame or screen that mounts to the lamp's metal reflector, usually on the perimeter of the reflector. A diffuser turns a parabolic-equipped light into a flood light with a broader, more diffused light pattern. When using a diffuser over a light, make sure there is sufficient room between the diffuser and the reflector to allow heat to escape (this is more important with hot lights than with strobes). The light should also have barn doors attached. As with all lights, they can be "feathered" by aiming the core of light away from the subject and just using the edge of the beam of light.

Spotlights. A spotlight is a hard-edged light source. Usually, it is a small light with a Fresnel lens attached. The Fresnel is a glass filter that focuses the spotlight, making the beam of light stay condensed over a longer distance. Barn doors are usually affixed to spots so that they don't spray light all over the set. Spots are often used to light a selective area of the scene, like a corner of the room or a portion of a seamless background. They are usually set to an output less than the key light or fill (although at times they may be used as a key light). Spots produce a distinct shadow edge, giving more shape to the subject's features than lower-contrast, diffused light sources. Although originally a hot light, various strobe manufacturers have introduced strobe versions of Fresnel spots.

LEFT—The Profoto MultiSpot offers a small, directional light source with a direct, sharply focused beam of light. **CENTER**—The Profoto ZoomSpot is a large, focusable, light-shaping tool designed to create stage lighting effects, accent lighting across huge distances, or for background projection. The zoom lens provides an adjustable light spread from 15 to 35 degrees. **RIGHT**—The Profoto Fresnel Spot is a classically sized spotlight that creates "movie light" with sharp, deep shadows and highly saturated color. This FresnelSpot offers lighting adjustments from 10 to 50 degrees.

"Barn doors are usually affixed to spots so that they don't spray light all over the set."

Grid Spots. Grid spots are honeycomb metal grids that snap onto the perimeter of the light housing. They come in 10-, 30-, and 45-degree versions, with the 10-degree grid being the narrower beam of light. Each comb in the honeycomb grid prevents the light from spreading out. Grid spots produce a narrow core of light with a diffused edge that falls off quickly to black. Because the light is collimated, there is very little spill with a grid spot. Grid spots provide a great amount of control because they allow you to place light in a specific and relatively small area. This makes them ideal for portraits where a dramatic one-light effect is desired. The light naturally feathers at its edge providing a beautiful transition from highlight to shadow. If the grid spot is the only frontal light used in a studio setting, the light will fall off to black, for a very dramatic effect.

Anthony Cava captured this remarkable portrait of an old friend who lived near his Ottawa studio. Anthony used a single strobe with a 10-degree grid spot at a steep angle so that the light was almost overhead. The light was at a skimming angle to the old man's skin to reveal texture and specular brilliance in the highlights. The grid spot narrowed the beam of light drastically so that the light became a narrow but intense shaft of light with a feathered edge.

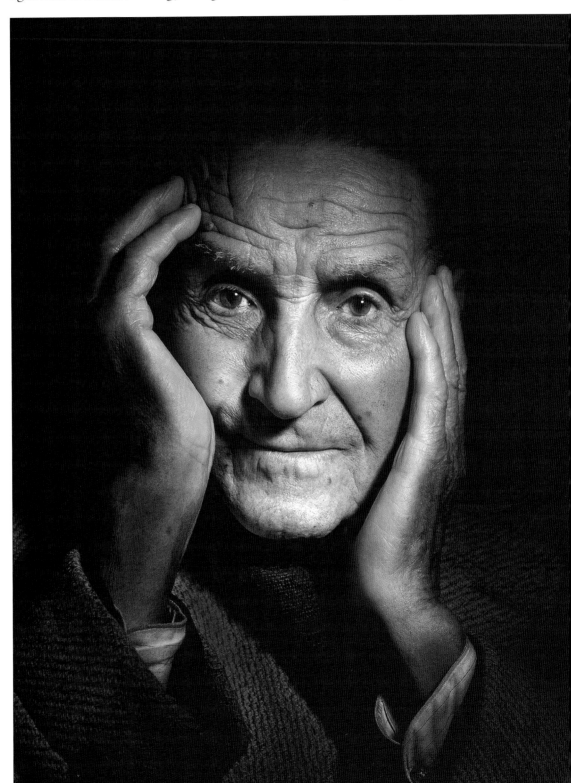

Snoots. Snoots are attachments that snap to the light housing and resemble a top hat. Snoots narrow the beam of light into a very thin core. They are ideal for small edge lights used from behind the subject.

Umbrellas. Umbrellas, while not as popular as they once were, are still useful for spreading soft light over large areas. They produce a rounded catchlight in the eyes of portrait subjects and, when used close to the subject, provide an almost shadowless light that shows great roundness in the human face.

Photographic umbrellas are either white or silvered, with the silver-lined models producing more specular, direct light than the matte white ones. When using lights of equal intensity, a silver-lined umbrella can be used as a key light because of its increased intensity and directness. It will also produce wonderful specular highlights in the over-all highlight areas of the face. A matte-white umbrella can then be used as a fill or secondary light. Umbrellas are usually used with a wide-angle reflector on the flash head.

Umbrellas fit inside a tubular housing in most studio electronic flash units, enabling you to better focus the beam of light for optimal effect. The umbrella slides toward and away from the flash head and is anchored with a set-screw or similar device. The optimal position occurs when the light strikes the full surface of the umbrella. If the umbrella is too close to the strobe, much of the beam of light will be focused past the umbrella surface and go to waste. If the light is too far from the umbrella surface, the perimeter of the beam of light will extend past the umbrella's surface, again wasting

Deborah Lynn Ferro used umbrellas to light the little girls in their active pose, as well as to achieve a clean white background with no flare. The background lights were about two stops hotter than the key light.

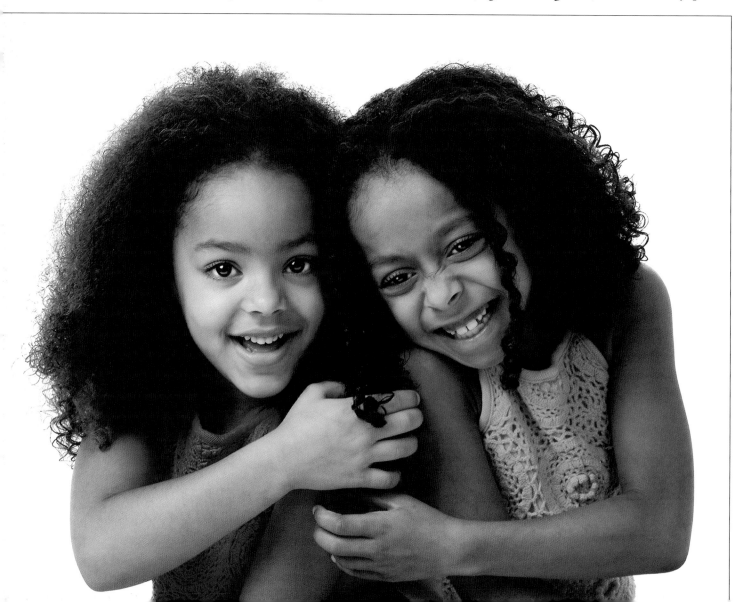

ABOVE—An umbrella is a beautiful light source to work with. When used close to the subject, it produces delicate wraparound lighting with no need for a fill source. Photograph by Mark Nixon **RIGHT**—Umbrellas come in a variety of sizes and shapes. Some have opaque backing for maximum light output. Some are translucent for shoot-through effects.

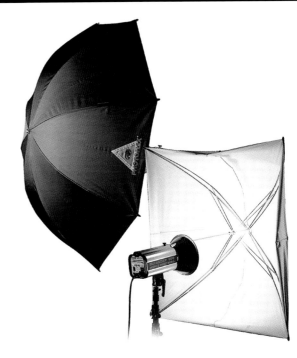

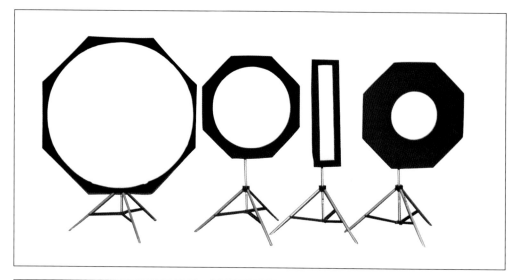

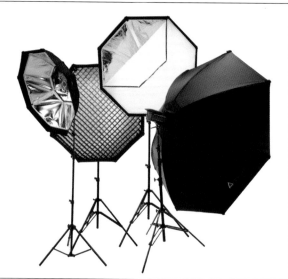

valuable light output. When setting up, this adjustment can be made using the modeling light.

Some photographers use a translucent umbrella, called a shoot-through umbrella, that is turned around so that the light shines through the umbrella and onto the subject. This gives a more directional light than when the light is turned away from the subject and aimed into the umbrella (bouncing it out of the umbrella and back onto the subject). There are many varieties of shoot-through umbrellas available commercially and they act very much like softboxes.

Softboxes. A softbox is like a tent housing for one or more undiffused strobe heads. Often, fiberglass rods provide rigid support for the housing. The frontal surface is translucent nylon, usually a double thickness. The sides are black on the outside and white on the inside to gather and diffuse more light. Softboxes come in many sizes and shapes. Although most are square or rectangular, there are also a few round and octagonal ones out there. The size ranges from 12-inches square all the way up to 5x7 feet. Softboxes are the ideal means of putting a lot of diffused light in a controlled area, and provide much more precise control over the light than umbrellas, which lose much of their light intensity to scatter.

A strip light, a popular tool in today's photography, is a long skinny softbox. Strip lights are used as background and hair lights in portraiture, as well as edge lights for contouring in tabletop photography. Sometimes they can be used as odd-shaped key lights, although they are usually so small and light that they can be tricky to use for this purpose.

Portable Flash

Portable flash is the most difficult of one-light applications. Portable flash units do not have modeling lights, so it is impossible to see the lighting effect before you take the picture. However, there are certain ways to use a portable flash in predictable ways to get excellent portrait lighting.

Diffused Flash. Direct on-camera flash should be avoided altogether for making portraits unless it is a fill-in source. Its light is too harsh and flat and it produces no roundness or contouring of the subject's face. However, when you diffuse on-camera flash, you get a softer frontal lighting similar to fashion lighting. While diffused flash is still a flat lighting and frontal in nature, the softness of it produces much better contouring than direct flash. There are various devices that can be used to diffuse on-camera flash. Many can even be used with your flash in auto or TTL mode, making exposure calculation effortless.

Bounce Flash. Bounce flash can be an ideal type of portrait light, because it is soft and directional. By bouncing the flash off a side wall, a white card aimed, or an umbrella at the subject, you can achieve an elegant type of wraparound lighting that illuminates the subject's face beautifully.

You must practice your geometry when using bounce flash. Aim the flash unit at a point on the wall or reflective surface that will produce the widest beam of light reflecting back onto your subject. If the only available wall is very far from the subject, it might be better to bounce the light off a large white card. Place this between one and three feet away from the flash unit for best results. (*Note:* The best way to position this is to use an assistant. If more than one reflector needs positioning, gaffer's tape and a light stand will work well—or use a second assistant. When on location, don't be afraid to recruit help from friends or family members of the subject.) For more on using reflectors in lighting, see page 29.

You should never bounce flash off colored walls. If you do, the light reflected back onto your subject will be the same color as the walls. Even if you use a white card to bounce the flash into, you may get some tinted light in the shadow areas of the face. Although you may be able to correct some of the tint with white balance, you will still get a noticeable color shift.

REMOTE-TRIGGERING DEVICES

If using multiple flash units to light an area, some type of remote triggering device will be needed to sync all the flash units at the instant of exposure. There are a variety of these devices available, but by far the most reliable is the radio remote-triggering device. When you press the shutter release, it transmits a radio signal that is received by individual receivers mounted to each flash. This signal can be transmitted in either digital or analog form. Digital systems, like the Pocket Wizard Plus, are state of the art. Complex 16-bit digitally coded radio signals deliver a unique code, ensuring the receiver cannot be triggered or "locked up" by other radio noise. The built-in microprocessor guarantees consistent sync speeds even under the worst conditions. Some photographers use a separate transmitter for each camera, as well as a separate one for the handheld flashmeter, allowing the photographer to take remote flash readings from anywhere in the room.

A good bounce-flash accessory is the Omni-Bounce, a frosted cap that fits over the flash head. The beam of light is diffused and can be used as a soft straight flash or in bounce mode for an even softer bounce effect. The Omni Bounce is made to fit the popular Canon and Nikon speedlights.

Bounce Flash Exposure. The best way to determine exposure is fire a bounce test and review it on the camera's LCD. If the scene requires more flash at the exposure settings you've established, add flash output in ⅓-stop increments or adjust exposure settings.

If using an integrated TTL (through-the-lens) flash system, set your basic exposure settings as if you were not using flash, turn on the flash unit, set the bounce mode and position of the flash head, then fire away. Evaluate the test exposure on the camera's LCD. If the ambient light is too bright or too dim, adjust exposure settings accordingly; if the flash exposure is too bright or too dim, adjust the flash output in ⅓-stop increments until you achieve the effect you desire.

Personally, I prefer the strobe exposure to be about ½ to 1 full stop more intense than the ambient light so that it is the dominant lighting in the scene. However, if you wish to incorporate some of the light in the room, you may lessen the flash output to make it more of a fill light. This is often desirable when window light is the defining light source. In this case, the flash is good for filling in shadows and reducing the lighting ratio.

TTL flash systems, particularly those made by Nikon and Canon, produce amazingly accurate exposures in bounce-flash mode. Further, the bounce-flash output can be set to correlate to the available light-meter reading in fractions of f-stops, meaning that you can set your flash to fire at ⅓ stop less intensity than the daylight reading, for perfect, unnoticeable fill flash. Conversely, you can set your bounce exposure to fire at one stop over your daylight reading to overpower problematic room light. The versatility of these systems is remarkable, and both manufacturers' systems have been refined over six and seven generations, making them virtually foolproof and fully controllable.

Bounce Flash Devices. There are a number of devices on the market that make using portable flash a little easier. One such device is the Lumiquest ProMax system, which allows 80 percent of the flash illumination to bounce off the ceiling while 20 percent is redirected forward as direct fill light. This solves the overhead problem of bounce flash off the ceiling. The system also includes interchangeable white, gold, and silver inserts, as well as a removable frosted diffusion screen.

This same company also offers the Pocket Bouncer, which enlarges and redirects light at a 90-degree angle from the flash to soften the quality of light and distribute it over a wider area.

While no exposure compensation is necessary with TTL flash exposure systems, operating distances are somewhat reduced. With both systems, light loss is approximately

1⅓ stops, however with the ProMax system, using the gold or silver inserts will lower the light loss to approximately ⅔ stop.

Hot Lights

The beauty of using hot lights, which are continuous-light sources, is that (unlike with flash) you can always see what you're going to get photographically. This can make it much more straightforward and efficient to adjust your lighting to flatter the subject and harmonize with the existing light in a scene.

Using hot lights, however, does require some care and safety. A 1K light draws 1000 watts of power from any circuit into which it is plugged. A standard household circuit (20 Amp) provides 2000 watts of power at maximum capacity, which means with two 1K lights you will be using the maximum amount of power available on that circuit. If there is any other electrical device running on that circuit (anywhere in the building), you will trip the circuit breaker and lose power. As a result, photographers who use hot lights frequently carry lots of long extension cords, allowing them to power the lights from different outlets and distribute the load evenly over the electrical system.

Hot lights are also hot. The bulbs, lenses, casings, and sometimes even the stands themselves get quite warm. For that reason, using heavy leather gloves is recommended when working with the lights. This is especially important when changing bulbs; the gloves will protect you from burns, but will also protect the new bulb from oils on your fingers that can be deposited on the bulb surface and cause the glass to explode (this is particularly true for quartz-halogen bulbs).

"The bulbs, lenses, casings, and sometimes even the stands themselves get quite warm."

Another good practice is to unplug lights before you attempt to change a bulb. Equally, you should make sure the lights are turned off at the switch before plugging them in. It's also recommended that you use sandbags to secure light stands that are extended into the air or have boom arms attached.

Daylight-Balanced Fluorescents

Daylight-balanced photographic fluorescent light sources, have become very popular among photographers. As continuous sources, they offer the same ease of use as hot lights, but without some of the problems. First, they are daylight-balanced (or just slightly warmer), sot they can be used seamlessly outdoors or with window light; there are no color-balance issues to worry about. Additionally, they are cool running, so fluorescents can be used in studio light modifiers, like softboxes, without concern.

Window Light

One of the most flattering types of lighting you can use in portraiture is window lighting. It is a soft light that minimizes facial imperfections, yet it is also directional with good modeling qualities. Window light is usually a fairly bright light source that will allow you to handhold the camera if a moderately fast ISO and wide lens aperture are used. Window light is infinitely variable, changing almost by the minute, allowing a great variety of moods in a single shooting session.

This unusual window-light portrait by Jeff Woods incorporates the texture-laden walls of an abandoned building. The window was large and allowed both direct and diffused light to pass through it. Jeff positioned his subject just out of the direct light (see the highlight on floor) and had her turn her head back toward the light. He used a reflector to camera left to help fill in the shadows. Note the unusual placement of a Victorian chair in a warehouse-type environment.

Of course, window lighting has several large drawbacks, as well. Since daylight falls off rapidly once it enters a window—it is much weaker just a few feet from the window than it is close to the window—great care must be taken in determining exposure. If the subject moves as little as six to eight inches, the exposure will change. Another draw-

back is that you cannot move the light source, so you must move your subject in relation to the window. This can sometimes result in odd poses. When shooting in buildings not designed for photography, you may also have to work with distracting backgrounds and at uncomfortably close shooting distances.

The best quality of window light is found in the soft light of mid-morning or mid-afternoon. Direct sunlight is difficult to work with because of its intensity and because it will often create shadows of the individual window panes on the subject. It is often said that north light is the best for window-lit portraits, but this is not necessarily true; beautiful light can be had from a window facing any direction, provided the light is soft.

"One of the most difficult aspects of shooting window light portraits is positioning your subject."

Subject Positioning. One of the most difficult aspects of shooting window light portraits is positioning your subject so that there is good facial modeling. If the subject is placed parallel to the window, you will get a form of split lighting that can be harsh. It is best to position your subject away from the window slightly so that he or she can look back toward the window. Thus, the lighting will highlight more of the face.

You can also position yourself between the window and your subject for a flat type of lighting. Often, however, you'll find that your body will block some much-needed light, or that the subject must be quite far from the window to get the proper perspective and composition. Under these circumstances, the light level will often be too low to make a decent exposure, even with a high speed ISO.

Usually, it is best to position the subject three to five feet from the window. This not only gives good, soft lighting, but also gives you a little extra room to produce a flattering pose and pleasing composition.

Metering. The best way to meter for exposure is with a handheld incident meter. Hold it in front of the subject's face in the same light, and take a reading, pointing the light-sensitive hemisphere directly at the camera lens.

If using a reflected meter, like the in-camera meter, move in close to the subject and take a reading off the subject's face. Most camera light meters take an average reading, so if you move in close on a person with a medium skin tone, the meter will read the face, hair, and what little clothing and background it can see and give you a fairly good exposure reading. If the subject is particularly fair-skinned, however, remember to open up at least one f-stop from the indicated reading. Always verify your exposure readings on the camera's LCD screen.

If using an average ISO (like ISO 100), you should be able to make a handheld exposure at a reasonable shutter speed like $\frac{1}{30}$ second with the lens opened up to f/2.8. Of course, this depends on the time of day and intensity of the light, but in most cases a handheld exposure should be possible. Since you will be using the lens at or near its widest aperture, it is important to focus carefully. Focus on the subject's eyes in a full-face or seven-eighths pose. If the subject's head is turned farther from the camera, as in a three-quarter view, focus on the bridge of the nose. Depth of field is minimal at these apertures, so control the pose and focus carefully for maximum sharpness on the face.

FACING PAGE—This portrait by Giorgio Karayiannis, called *Joe and Bunny*, includes the window as a compositional element. You can see the softbox-like effect of the light source and the abrupt falloff of the light once it enters the window and wraps around the subject. By positioning his subject to look up into the light, and photographing from the side, Giorgio created elegant portrait light with great modeling features.

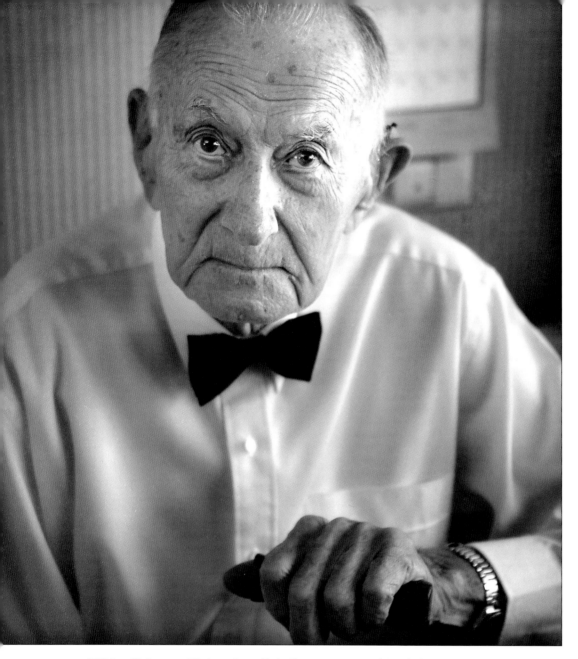

White Balance. If shooting digitally, a custom white-balance reading should be taken, since most window-light situations will be mixed light (daylight and room light). If working in changing light, take a custom white-balance reading every ten to twenty minutes or so to ensure that the changing light does not affect the color balance of your scene. (*Note:* The ExpoDisc is ideal for these situations with ambient room light plus daylight.)

Fill-in Illumination. One of the biggest problems commonly encountered with window light is that there is not adequate fill light to illuminate the shadow side of the subject's face.

Reflected Light. The easiest way to fill the shadows is with a large white or silver reflector placed next to the subject on the side opposite the window and angled to direct the light back into the face.

Room Lights. If you are shooting a three-quarter- or full-length portrait, a fill reflector may not be sufficient; you may need to provide another source of illumination to achieve a good fill-in balance. Sometimes, if you flick on a few room lights, you will

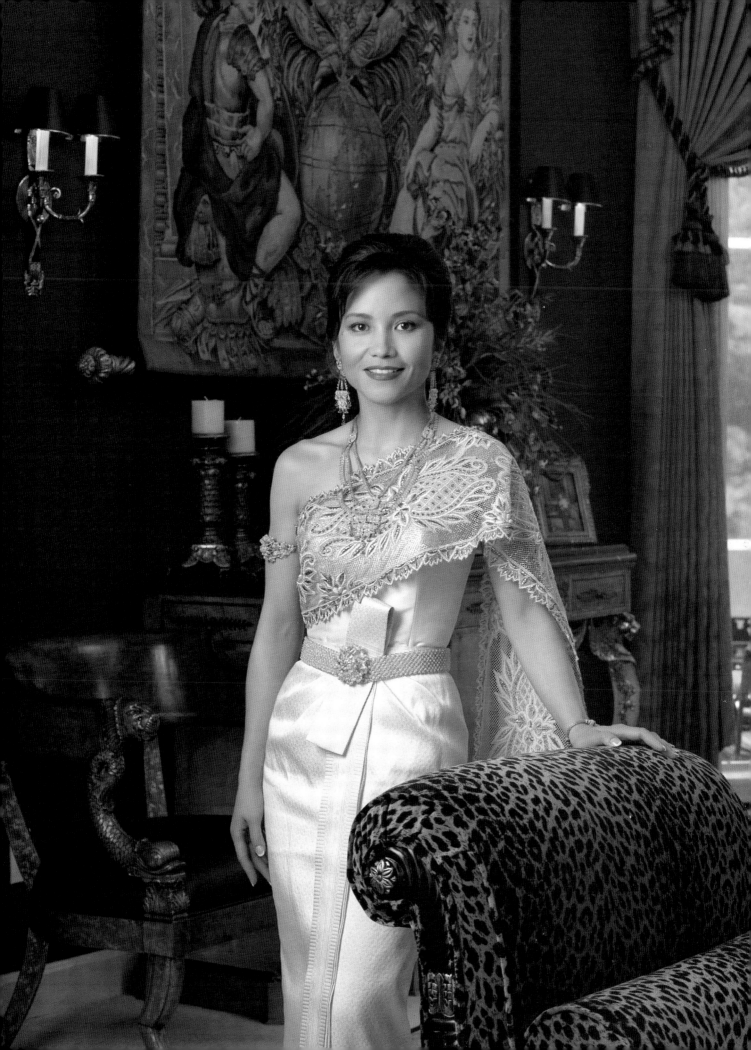

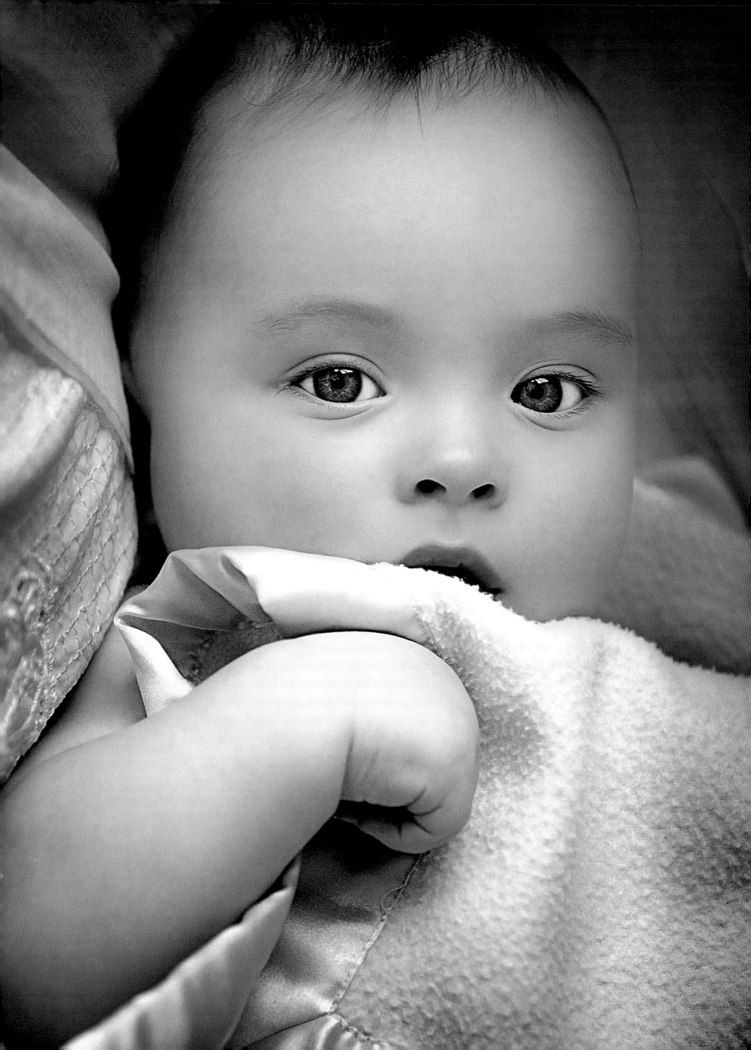

get good overall fill-in. Be sure, however, not to overpower the window light—otherwise, you will produce a strange lighting pattern with an unnatural double key-light effect. (*Note:* If you select a daylight white-balance setting, you will get a warm glow from the tungsten fill lights when using them for fill-in light. This is not objectionable as long as the light is diffused and not too intense.)

To measure the intensity of the fill light, take one light reading from the shadow side of the face and another from the highlight side. There should be at least a half to one full f-stop difference between the highlight and shadow sides of the face.

In general, it is a good idea to have some room light in the background behind the subject. This opens up an otherwise dark background and provides better depth in the portrait. If possible, position the background room light out of view of the camera, either behind the subject or off to the side. If seen behind the subject, a bright light can be distracting.

Bounce Flash. If none of the above methods of fill-in is available to you, use bounce flash. You can bounce the light from a portable electronic flash into an umbrella or off a white card, the ceiling, or a wall, but be sure that it is a half to one full f-stop less intense than the daylight. When using flash for fill, it is important to either carry a flashmeter for determining the intensity of the flash or to use an automated TTL flash system, which can accurately incorporate the daylight, flash, and other light sources into a proper exposure.

"In general, it is a good idea to have some room light in the background behind the subject."

Diffusing Window Light. If you find a nice location for a portrait but the light coming through the windows is direct sunlight, you can diffuse the window light with a large acetate scrim called a flat.

Flats are sold commercially in sizes up to eight feet long, but you can also make your own by attaching diffusion material (like frosted shower-curtain material) to a lightweight frame. Then, lean the flat in the window at a height that diffuses the light falling on your subject. Remember, the larger the flat, the more diffused your light source will be. (*Note:* You can also diffuse the light by taping the diffusing material in place inside the window frame with gaffer's tape.)

Light diffused in this manner has the warm feeling of sunlight but without the harsh shadows. In fact, the light is so scattered that it is often difficult to see a well-defined lighting pattern. Because the sunlight is scattered so much by the diffusing material, you will often find that you don't need a fill-in source at all. Even without fill, it is not unusual to have a low lighting ratio in the 2:1 to 3:1 range (see chapter 3 for more on lighting ratios).

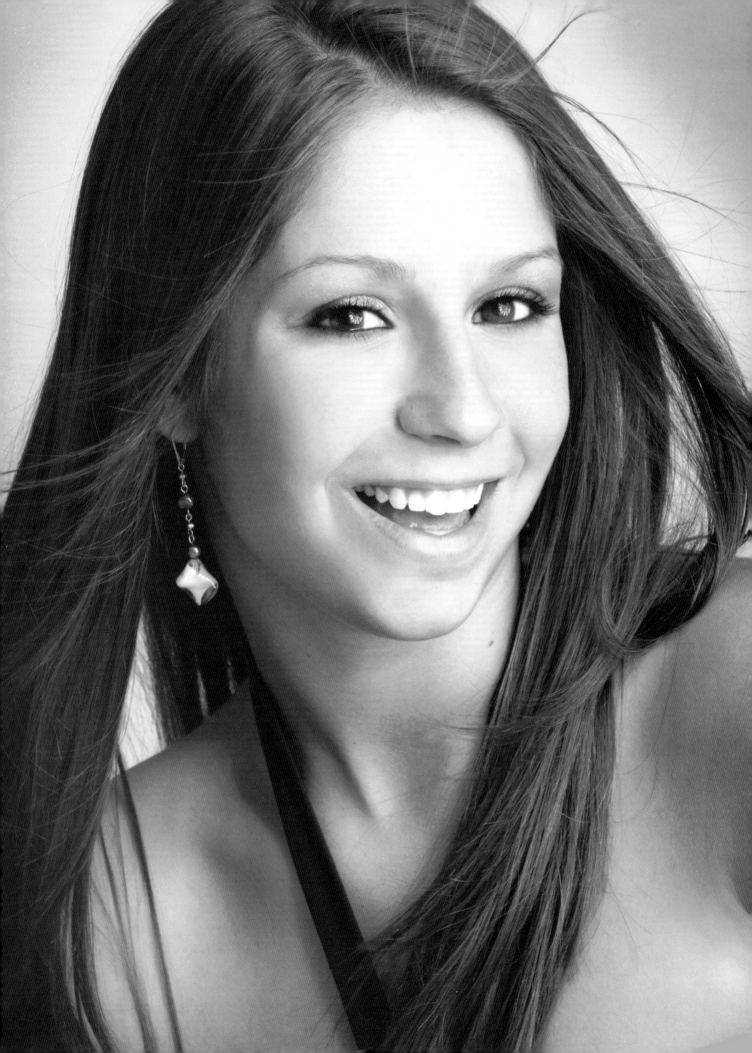

3. Portrait Lighting Basics

The human face is sculpted and round; it is the job of the portrait photographer to reveal these contours. This is done primarily with highlights and shadows. Highlights are areas that are illuminated by a light source; shadows are areas that are not. The interplay of highlight and shadow creates the illusion of roundness and shows form. Just as a sculptor models the clay to create the illusion of depth, so light models the shape of the face to give it depth and dimension.

As noted on page 28, the lights that create virtually all lighting patterns and effects are the key light and the fill light. In this chapter, we will look at these critical lights in greater detail—and explore additional lights can be added selectively to enhance your results.

Key Light

The function of the key is to shape the subject. It should draw attention to the front plane (the "mask") of the face. Where you place the key light will determine how the subject is rendered. You can create smoothness on the subject's face by placing the light near the camera and close to the camera/subject axis, or you can emphasize texture and shape by skimming the light across the subject from the side.

The key light should be a high-intensity light. If using diffusion, such as an umbrella or softbox, the assembly should be supported on a sturdy stand or boom arm to prevent it from tipping over. If undiffused, the key light should have barn doors affixed to control the light and prevent lens flare.

FACING PAGE—Here is another example of a really big key light. Charles Maring often uses a 7-foot Profoto reflector as a single key light with no fill. In the close-up of the senior's eyes (below), you can see the differentiated interior of the round reflector, with varying degrees of reflectivity mirrored in her eyes. A single strobe fired into this reflector created this amazingly soft wraparound lighting. The exposure was at f/16 to keep all the girl's hair in focus.

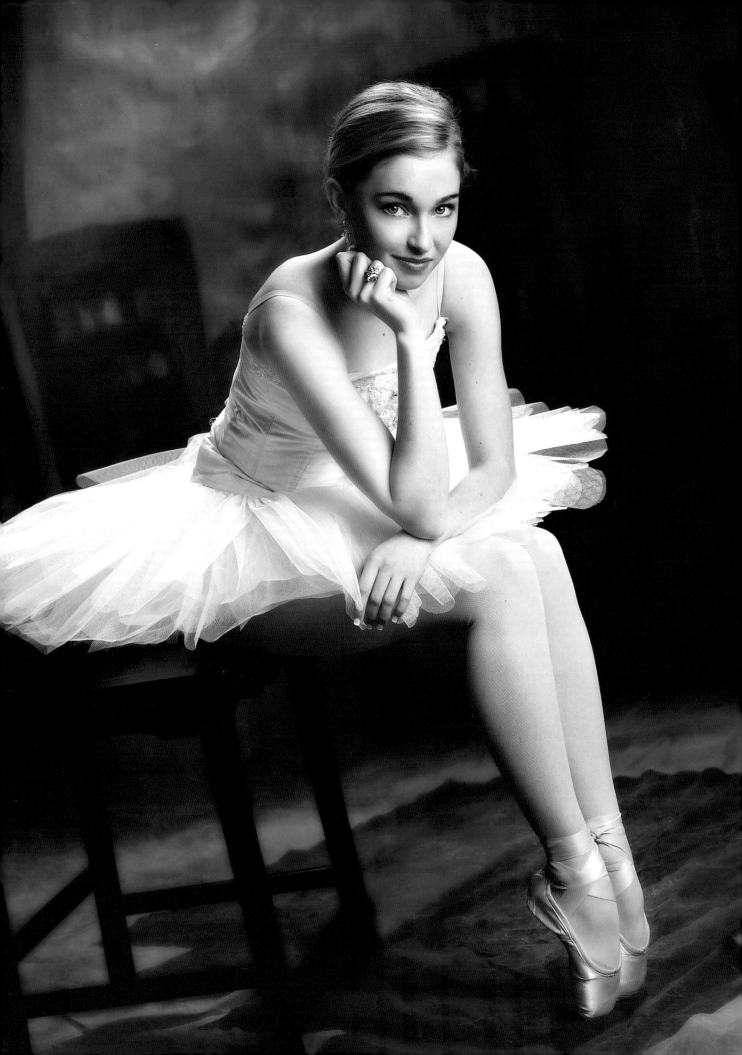

Chris Nelson photographed this young lady with a softbox as a main light. He used a silvered reflector for fill, a strip light for the hair light, and a background light. The softbox and strip light were set to the same output level; the background light was set to a stop less. The camera angle was about a foot over the subject using a telephoto lens. He used a fan on low to give her hair some fill and lift. Chris says of this pose, "Never use it unless your subject has long sleeves on, and don't use it if the arms are abnormally large or well developed."

In most cases, the key light is placed above and to the side of the face so that it illuminates both eye sockets and creates a shadow on the side of the nose. The nose shadow should not cross over onto the cheek, nor should it go down into the lip area.

When the face is turned for posing, the key light must also be moved to maintain the lighting pattern. For example, the light will be positioned at approximately a 45-degree angle to the camera when photographing the full face of a subject. However, when the subject turns to show the camera a two-thirds facial view, the key light will need to shift with the camera to maintain the same lighting pattern as in the first shot.

Normally, you will want to position the main light close to your subject without it appearing in the frame. A good working distance for your key light, depending on your room dimensions, is eight to twelve feet. Sometimes, however, you will not be able to get the skin to "pop," regardless of how many slight adjustments you make to the key light. This probably means that your light is too close to the subject. Move the light back or feather it.

To get an accurate exposure reading, position a handheld exposure meter directly in front of the subject's face and point it toward the light source. Make a few exposures and verify the exposure on the camera's LCD. If your system allows you to check a histogram of the exposure, check it to make sure you have a full range of highlight and shadow detail.

Fill Light. Just as the key light defines the lighting, the fill light augments it, controlling the lightness or darkness of the shadows created by the key light. Because it does not create visible shadows, the fill light is defined as a secondary light source.

The fill light should always be diffused. If it is equipped with a simple diffuser, a piece of frosted plastic or acetate in a screen or frame that mounts over the parabolic reflector, it should also have barn doors attached. If using a more diffused light source,

"Normally, you will want to position the main light close to your subject without it appearing in the frame."

such as an umbrella or softbox, be sure that you are not "spilling" light into unwanted areas of the scene, such as the background. As with all lights, these units can be feathered, aiming the core of light away from the subject and just using the edge of the beam of light (see page 79).

The best place for the fill source is as close as possible to the camera-to-subject axis. All lights, no matter where they are or how big, create shadows. By placing the fill light as near the camera as possible, all the shadows that are created by that light are cast behind the subject and are less visible to the camera.

When placing the fill light, keep a watch out for unwanted highlights. If the fill light is too close to the subject, it often produces its own set of specular highlights, which show up in the shadow area of the face and make the skin appear oily. If this is the case, move the camera and light back slightly, or move the fill light laterally away from the camera slightly. You might also try feathering the fill light in toward the camera a bit. This method of limiting the fill light is preferable to closing down the barn doors or lowering its intensity.

The fill light can also create multiple catchlights in the subject's eyes. These are small specular highlights in the iris. The effect of two catchlights (one from the key light, one from the fill light) is to give the subject a vacant stare or directionless gaze. This second set of catchlights is usually removed in retouching.

In this beautiful glamour portrait by Tim Schooler, the key light comes from behind the subject a little to camera right. You can determine this because the right side of her face and nose are highlighted. The fill light, which is close to the same intensity as the key light, comes from camera left and fills the shadow side of the model's face. Additional fill is achieved by the white crepe material, which is reflecting light everywhere within the scene. You will notice that even though the lights are fairly even in intensity, the key light still provides direction and bias.

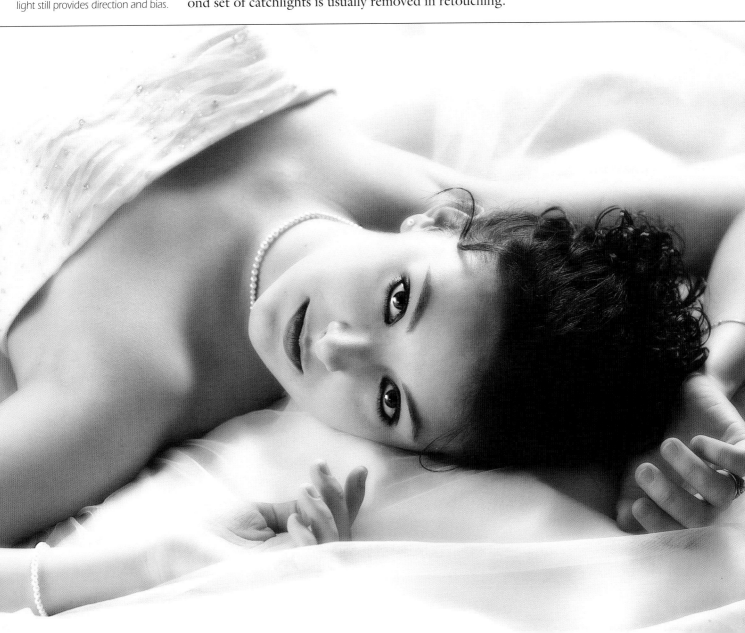

In simplified lighting patterns, the source of the fill light may not be a light at all but a reflector that bounces light back onto the subject. This means of fill-in has become quite popular in all forms of photography. The reflectors available today are capable of reflecting any percentage of light back on to the subject, from close to complete reflectance with various mirrored or Mylar-covered reflectors to a very small percentage of light with other types. Reflectors can also be adjusted almost infinitely just by finessing the angle at which they are reflecting the fill light.

LEFT—Stacy Bratton captures her kids with lots of soft light. She uses the a large softbox parallel to the floor to produce a signature square or rectangular catchlight. She also uses, what she calls an "up-light," which is light bounced into a reflective ceiling just above the set. This light acts as fill light and softens the features of all her subjects. **FACING PAGE**—Master photographer Drake Buseth often uses the outdoors as his studio. Even so, a key light and fill light are still called for. Here, a large softbox was used over the lens as the key light and a large reflector was angled up from beneath the camera as a fill-in source. The effect produces a gentle lighting ratio.

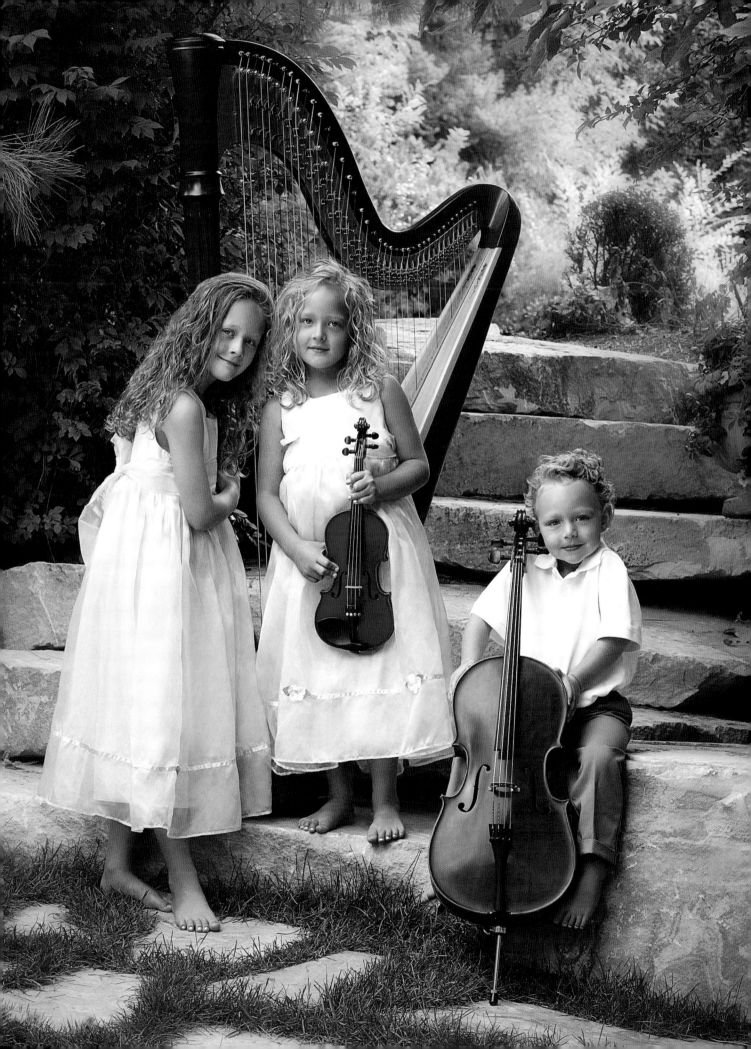

THE PERFECT FILL

If it were a perfect world, fill light would be shadowless, large, and even—encompassing every part of the subject from top to bottom and left to right. The fill light would be soft and forgiving and variable. And it would complement any type of key lighting introduced.

Just such an effect can be created using strobe heads in wide-angle reflectors bounced into a white or neutral gray wall, or a flat behind the camera (the surface must be neutral to ensure no color cast is introduced). Usually, the first two lights are placed to either side of the camera, then the third is placed over the camera and aimed high off the flat or the wall/ceiling intersection. These lights are placed close to the wall and ceiling, creating a wall of soft light.

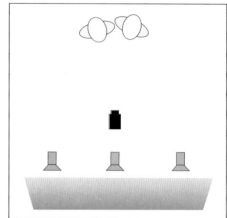

These fill lights are then balanced to produce an identical output across the subject. The key light, which may be placed to the side or above the subject, will be equal to or more intense than the fill source, creating a ratio between the fill and key lights (see pages 64–68 for more on lighting ratios).

Three studio strobes in wide-angle reflectors are bounced into the rear wall behind the camera to provide a blanket of fill light on the subjects. The lights are adjusted to produce the same exposure across the subjects.

A variation on this setup is to rig a large white flat over and behind the camera. Two or three strobe heads can then be bounced into the flat for the same effect as described above. Some of the light is bounced off the flat and onto the ceiling, providing a very large envelope of soft light.

Background Light

A background light creates depth and enhances the separation between the subject and the background. It's a good idea to leave about five feet from your subject to the background area so that you can comfortably place a light behind the subject. If used on a set, the background light should be hidden below the subject and aimed at the background. If used on location, it can be out of frame and aimed at the background scene.

If the background has more light on it than the subject, it will reproduce lighter than it actually is. If the background has less light on it than the subjects, it will reproduce darker than it is. If you want the background to reproduce as the same color that it is, the light on the background should be equal to the amount of light on your subject (i.e., the same intensity as your key light). On location, this technique often produces an unwanted emphasis on the background, so most photographers will opt for reduced light output on the background in these situations.

Regardless of intensity, the background light should mimic, or be similar to your main lighting scheme; i.e., coming from the same general direction as the key light. Then, the darker, shadowed side of the face will be against the darker area of the background, which will keep the viewer's eyes focused on the frontal mask of the face. If the shadowed side of the face is against the lighter side of the background, the viewer's eyes will be drawn to an area of the picture behind the subject, which is not something you want to do. All of your lighting efforts should be to draw visual emphasis to the subject of the portrait.

Hair Light

The hair light, which is optional (and often excluded in simple setups), is a small light placed above the subject to add shine on the hair and create additional separation between the subject and background. The hair light, which is always used opposite the key light and slightly behind the subject, should light the hair only and not skim onto the face. Frequently, the hair light is fitted with a smaller parabolic reflector and adjusted to a reduced power setting. Hair lights are almost always used undiffused, but barn doors or a snoot are a necessity. Because this light is placed behind the subject, the light will create flare if such controls are not used.

Chris Nelson made this striking close-up portrait with a softbox as a main light; a reflector was used on camera right and an umbrella was used above the camera, aimed straight in at the model, but feathered upward slightly to put more light on her red hair than her white sweater. The umbrella was set to output one stop less light than the main light. Crumpled gold Mylar was used as a background and a strip light, set at the same output as the softbox, was used as a hair light. The strip light was positioned above and behind the subject.

Kicker Lights

Kickers are optional lights used very much like hair lights; they add highlights to the sides of the face or body to increase the feeling of depth and richness in a portrait. Because they are used behind the subject, the light just glances off the skin or clothing and produces highlights with great brilliance. Barn doors or snoots should be used to control these lights.

Setting the Lights

Most photographers have their own procedures for setting the portrait lights. You will develop your own system as you gain experience, but the following is a plan you can start with.

Background Light. Generally, the first light you should set is the background light (if you are using one). Place the light behind the subject, illuminating the part of the background you want lit. Usually the background light is slightly hotter very close to the subject and fades gradually the farther out from the subject you look. This is accomplished by angling the light downward. If you

"Examine the subject's face with only the fill light on and determine if the skin looks oily or normal."

have more space in front of than behind the subject in the composition, the light should be brighter behind the subject than in front (as seen from the camera). This helps increase the sense of direction in the portrait. The background light is usually set up while all other lights are turned off.

Hair Light. Next, the hair light (if using one) is set. This is also set up with your frontal lights extinguished so that you can see any stray light falling onto the face. If this happens, adjust the light until it illuminates only the hair. When photographing men, the hair light can sometimes double as a kicker, illuminating the hair and one side of the forehead or cheek simultaneously.

Fill Light. Next, the fill light is set. Usually it is placed next to the camera (see the lighting diagrams on pages 72–73). Adjust it for the amount of shadow detail and lighting ratio you want to achieve. Examine the subject's face with only the fill light on and determine if the skin looks oily or normal. Sometimes you will have to use a pancake base makeup to dry up excessively moist skin if adjusting the fill light won't correct the problem. If the skin looks too matte and lifeless, increase the amount of fill.

Key Light. Finally, turn on the key light and adjust it for the lighting pattern and ratio you desire. Move it closer to or farther from the subject to determine the ratio you want. Ratios (see below) are best metered by holding an incident light meter first in front of the shadow side of the face, and then in front of the highlight side—in each case pointing the meter directly at the light source. Meter the lights independently with the other extinguished. This will give you an accurate reading for each light. Meter the exposure with both frontal lights on and the incident-light dome pointing directly at the camera lens.

Lighting Ratios

A lighting ratio is a numeric expression of the difference in intensity between the shadow and highlight side of the face in portraiture. A ratio of 3:1, for example, means that the

FACING PAGE—In this fine portrait by Greg Phelps you see the effects of kickers placed behind the subject to reveal textural details on the side of the face or in the hair. Here, a kicker was used on either side of the subject. Lights set behind the subject and aimed forward need to be directional to avoid light being cast on the lens, which would cause flare. Greg likes using strip lights (small vertical softboxes) for these effects. The backlight to camera right was less intense than the one to camera left, which produced a strong edge light on the hair and shoulder of the subject.

Moderate lighting ratios provide good modeling but are still gentle, as seen in this image by Deborah Lynn Ferro.

highlight side of the face has three units of light falling on it, while the shadow side has only one unit of light falling on it. Ratios are useful because they describe how much local contrast there will be in the portrait. They do not, however, reflect the overall contrast of the scene.

Since lighting ratios tell you the difference in intensity between the key light and the fill light, the ratio is an indication of how much shadow detail you will have in the final portrait. Since the fill light controls the degree to which the shadows are illuminated, it is important to keep the lighting ratio fairly constant. A desirable ratio indoors or out is 3:1. This ratio guarantees both highlight and shadow detail and is useful in a wide variety of situations.

Determining Lighting Ratios. There is considerable debate and confusion over the calculation of lighting ratios. This is principally because you have two systems at work, one arithmetical and one logarithmic. F-stops are in themselves a ratio between the size of the lens aperture and the focal length of the lens, which is why they are expressed as "f/2.8," for example. The difference between one f-stop and the next full f-stop is either half the light or double the light. For example f/8 lets in twice as much light through a lens as f/11 and half as much light as f/5.6. However, when we talk

about lighting ratios, each full stop is equal to two units of light, each half stop is equal to one unit of light, and each quarter stop is equivalent to half a unit of light. This is, by necessity, a suspension of disbelief—but it makes the lighting-ratio system explainable and repeatable.

In lighting of all types, from portraits made in diffused sunlight to editorial portraits made in the studio, the fill light is always calculated as one unit of light, because it strikes both the highlight and shadow sides of the face. The amount of light from the key light, which strikes only the highlight side of the face, is added to that number. For example, imagine you are photographing a small family group and the key light is one stop (two units) greater than the fill light (one unit). The one unit of the fill is added to the two units of the key light, yielding a 3:1 ratio; three units of light fall on the highlight side of the face, while only one unit falls on the shadow side.

Lighting Ratios and Their Unique Personalities. A 2:1 ratio is the lowest lighting ratio you should employ. It reveals only minimal roundness in the face and is most desirable for high-key effects. High-key portraits are those with low lighting ratios, light tones, and usually a light or white background (see page 83). In a 2:1 lighting ratio, the key and fill-light sources are the same intensity (one unit of light falls on the shadow and highlight sides of the face from the fill light, while one unit of light falls on the high-

High lighting ratios provide a dramatically sculpted look, as seen in this image by Tim Schooler.

light side of the face from the key light—1+1:1=2:1). A 2:1 ratio will widen a narrow face and provide a flat rendering that lacks dimension.

A 3:1 lighting ratio is produced when the key light is one stop greater in intensity than the fill light (one unit of light falls on both sides of the face from the fill light, and two units of light fall on the highlight side of the face from the key light—2+1:1=3:1). This ratio is the most preferred for color and black & white because it will yield an exposure with excellent shadow and highlight detail. It shows good roundness in the face and is ideal for rendering average-shaped faces.

A 4:1 ratio (the key light is 1½ stops greater in intensity than the fill light—2+1+1:1=4:1) is used when the photographer wants a slimming or dramatic effect. In a 4:1 ratio, the shadow side of the face loses its slight glow and the accent of the portrait becomes the highlights. Ratios of 4:1 and higher are considered appropriate low-key portraits. Low-key portraits are characterized by a higher lighting ratio, dark tones, and usually a dark background (see page 84).

A 5:1 ratio (the key light is two stops greater than the fill light—2+2+1:1=5:1) is considered almost a high-contrast rendition. It is ideal for adding a dramatic effect to your subject and is often used in character studies. Shadow detail is minimal with ratios of 5:1 and higher. As a result, they are not recommended unless your only concern is highlight detail.

Most seasoned photographers have come to recognize the very subtle differences between lighting ratios, so fractional ratios (produced by reducing or increasing the fill light amount in quarter-stop increments) are also used. For instance, a photographer might recognize that with a given face, a 2:1 ratio does not provide enough roundness and a 3:1 ratio produces too dramatic a rendering, thus he or she would strive for something in between—a 2.5:1 ratio.

4. Portrait Lighting Styles

Portrait lighting imitates natural lighting. It is a one-light look. In other words, even though numerous lights may be used, one light must dominate and establish a pattern of shadows and highlights on the face. The placement of the key light is what creates this lighting pattern in studio portraiture, but it is the shape of the subject's face that usually determines what basic lighting pattern should be used. You can widen a narrow face, narrow a wide face, hide poor skin, and disguise unflattering facial features, such as a large nose—all by thoughtful placement of your key light.

"One light must dominate and establish a pattern of shadows and highlights on the face."

Broad and Short Lighting

There are two basic types of portrait lighting: broad lighting and short lighting.

Broad Lighting. Broad lighting means that the key light illuminates the side of the face turned toward the camera. Broad lighting is used less frequently than short lighting because it tends to flatten out and de-emphasize facial contours. It can be used to widen a thin or long face.

Short Lighting. Short lighting means that the key light illuminates the side of the face turned away from the camera. Short lighting emphasizes facial contours and can be used as a corrective lighting technique to narrow a round or wide face. When used with a weak fill light, short lighting produces a dramatic lighting with bold highlights and deep shadows.

The Five Basic Portrait-Lighting Setups

There are five basic portrait lighting setups. As you progress through them from Paramount to split lighting, each progressively makes the face slimmer. Each also progressively brings out more texture in the face because the light is more to one side.

Additionally, as you progress from Paramount to split lighting, you'll notice that the key light mimics the path of the setting sun—at first high, and then gradually lower in relation to the subject. It is important that the key light never dip below subject/head height. In traditional portraiture this does not occur, primarily because it does not occur in nature; light from the sun always comes from above.

ABOVE—This image by Greg Phelps is a good example of broad lighting, where the key light illuminates the side of the face turned towards the camera. According to Greg, this was a very simple shot. "I just sat the athlete down on a wooden foot locker, and there was a dark gray equipment locker behind him. I used only one light, a Chimera strip light with a fabric grid. The light was placed way to camera-left, so it was pretty much behind him—just skimming across his arm and face. The light was around to the left so far that I used an additional gobo to help shade the camera. In Photoshop, I darkened down the areas I thought were a little too light and did some minor retouching on his face." **FACING PAGE**—Short lighting occurs when the key light illuminates the side of the face turned away from the camera, as is shown here in this lovely portrait by Greg Phelps. He describes the shot: "There are two small windows in this room about two feet square, ten feet apart, and about six feet off the floor. That was the only light; no reflector or anything else. The walls were a light grey, so after the fact I had to build a wall in Photoshop. Just to the left of the painting there was a really ugly door leading into an even uglier room, so I just extended the wall to cover the door. I cleaned up the floor a little, as it was pretty nasty looking and then I vignetted the image. I try to keep Photoshop out of my work as much as possible. I try to use it only for normal facial retouching and burning in. But sometimes, as in this case, its other capabilities come in handy."

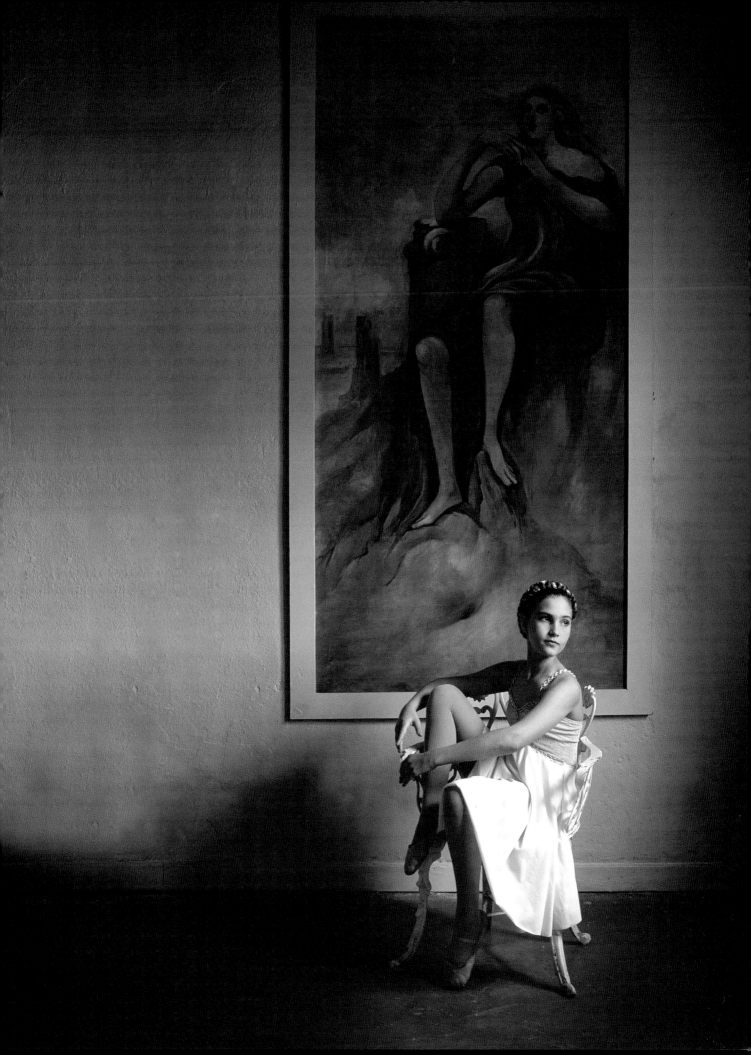

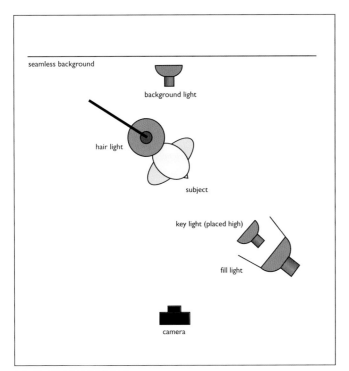

PARAMOUNT LIGHTING

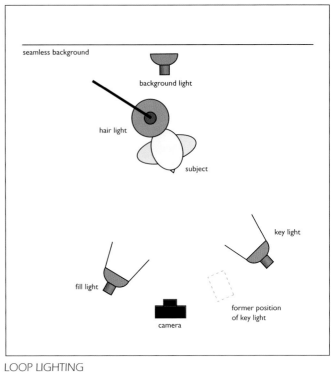

LOOP LIGHTING

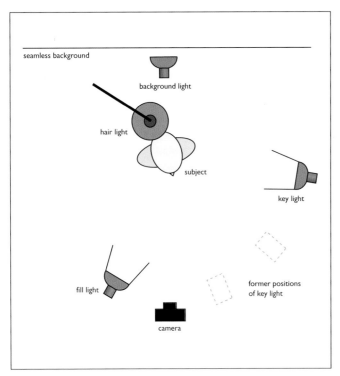

REMBRANDT LIGHTING

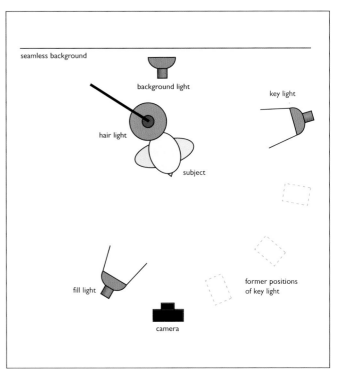

SPLIT LIGHTING

The setups described in this chapter presume the use of parabolic lights. However, you can duplicate the five lighting patterns described here using softboxes for key lights and reflectors as fill-in sources. Very little changes, with the exception that the key light is usually placed closer to the subject in order to capitalize on the softest light. In such soft-light setups, the background, hair, and kicker lights may be diffused as well—for

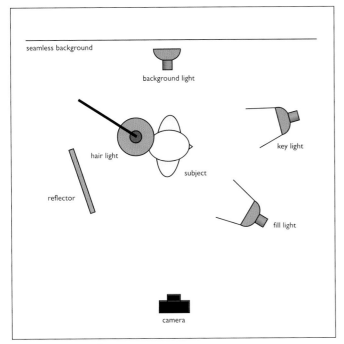

PROFILE LIGHTING

FACING PAGE—*These diagrams show the five basic portrait lighting setups. The fundamental difference between them is the placement of the key light. Lighting patterns change as the key light is moved from close to and high above the subject to the side of the subject and lower. The key light should not be positioned below eye level, as lighting from beneath does not occur in nature. You will notice that when the key and fill lights are on the same side of the camera, a reflector is used on the opposite side of the subject to fill in the shadows.*

instance, strip lights and similar devices can be used to produce soft, long highlights in hair, on the edge of clothes, and on the background. Although most contemporary portrait photographers have been trained to use parabolic lighting, many now prefer to use diffused light sources, which are more forgiving and do not create sharp-edged shadows.

Paramount Lighting. Paramount lighting, sometimes called butterfly lighting or glamour lighting, is a traditionally feminine lighting pattern that produces a symmetrical, butterfly-like shadow beneath the subject's nose. It tends to emphasize high cheekbones and good skin. It is generally not used on men because it tends to hollow out their cheeks and eye sockets.

The key light is placed high and directly in front of the subject's face, parallel to the vertical line of the subject's nose (see diagram on facing page). Since the light must be high and close to the subject to produce the desired shadow, it should not be used on women with deep eye sockets, or no light will illuminate the eyes. The fill light is placed at the subject's head height, directly under the key light. Since both the key and fill lights are on the same side of the camera, a fill card must be used opposite these lights and in close to the subject to fill in the deep shadows on the neck and shaded cheek.

The hair light, which is always used opposite the key light, should light the hair only and not skim onto the face of the subject. The background light, used low and behind the subject, should form a semicircle of illumination on the seamless background (if using one) so that the tone of the background grows gradually darker the farther away from the subject you look.

Loop Lighting. Loop lighting is a minor variation of Paramount lighting. The key light is lowered and moved more to the side of the subject so that the shadow under the nose becomes a small loop on the shadow side of the face. This is one of the more commonly used lighting setups and is ideal for people with average, oval-shaped faces.

In loop lighting, the fill light is positioned on the camera–subject axis. It is important that the fill light not cast a shadow of its own in order to maintain the one-light character of the portrait. The only place you can really observe if the fill light is doing its job is at the camera position. Look to see if the fill light is casting a shadow of its own by looking through the viewfinder.

The hair light and background light are used in the same way as they are in Paramount lighting.

Rembrandt Lighting. Rembrandt lighting (also called 45-degree lighting) is characterized by a small, triangular highlight on the shadowed cheek of the subject. The lighting takes its name from the famous Dutch painter who popularized this dramatic style of lighting. This type of lighting is often considered a masculine style and is com-

monly used with a weak fill light to accentuate the shadow-side highlight.

The key light is moved lower and farther to the side than in loop and Paramount lighting. In fact, the key light almost comes from the subject's side, depending on how far the head is turned away from the camera.

The fill light is used in the same manner as it is for loop lighting. The hair light, however, is often used a little closer to the subject for more brilliant highlights in the hair. The background light is in the standard position.

In Rembrandt lighting, kickers are often used to delineate the sides of the subject's face and to add brilliant highlights. Be careful when setting such lights not to allow

Bill McIntosh created this homage to Hollywood lighting using a 31-inch umbrella as a key light and a weak umbrella fill light, about three stops less than the key light intensity. You can see the Paramount lighting pattern on the man produces a small butterfly-like shadow under the nose. The woman, because her head was turned slightly away from light, has more of a loop lighting pattern. A characteristic of the Hollywood style was the weak fill light, which enhanced not only the lighting contrast, but the dramatic nature of the lighting.

them to shine directly into the camera lens; this will cause flare. The best way to check is to place your hand between the subject and the camera on the axis of the kicker. If your hand casts a shadow when it is placed in front of the lens, the kicker is shining directly into the lens and should be adjusted.

Split Lighting. Split lighting occurs when the key light illuminates only half the face. It is an ideal slimming light. It can be used to narrow a wide face or a wide nose. It can also be used with a weak fill to hide facial irregularities. Split lighting can be used with no fill light for a highly dramatic effect.

In split lighting, the key light is farther to the side of the subject and lower. In some cases, it is slightly behind the subject, depending on how far the subject is turned from the camera. The fill light, hair light, and background light are used normally.

The lighting on this beautiful Bill McIntosh portrait is deceptively simple. The subject is Lenoir Chambers, Virginia writer and 1962 Pulitzer Prize winner. Three strobes were used, two with barn doors, one on the background. The main light was positioned in front of and to the right of the subject (notice the shadows), and feathered beautifully. An umbrella fill was placed behind the camera. The image was shot using an Mamiya RZ67 camera, a 65mm lens, and Kodak Vericolor 160 film exposed at f/11.

Profile Lighting. Profile or rim lighting is used when the subject's head is turned 90 degrees from the camera lens. It is a dramatic style of lighting used to accent elegant features. It is used less frequently now than in the past, but remains a stylish type of portrait lighting.

In rim lighting, the key light is placed behind the subject so that it illuminates the profile and leaves a highlight along the edge of the face. The key light will also highlight the hair and neck of the subject. Care should be taken so that the core of the light is centered on the face and not too much on the hair or neck.

The fill light is moved to the same side of the camera as the key light and a reflector is used to fill in the shadows (see the profile lighting diagram on page 73). An optional hair light can be used on the opposite side of the key light for better tonal separation of the hair from the background. The background light is used normally.

Larry Peters created this fine profile portrait using rim light from a softbox behind and to the left of the camera. The light was feathered, using the edge of the light to produce texture on the young man's skin. An undiffused hair light was placed above and to the right of the camera (from behind the subject) and produced an edge highlight on his collar and hair. Larry also used a reflector to spill some light onto the frame of the Versace sunglasses. Very little frontal fill was used to keep the portrait edgy.

5. Techniques for Portrait Lighting

This image by Tim Schooler uses a very large, horizontally oriented softbox close to his senior subject. No fill was used so that a strong lighting ratio would be produced. Notice the very gradual transition from highlight to shadow on her face. This is the effect of the highly scattered light.

Working with One Light

If you want to improve your portrait lighting techniques drastically and in a relatively short time, learn to use one light to do the job of many. One light can effectively model the features of a single subject, or even a group of up to three people, with relative ease. Whether you own strobe, portable or studio flash equipment, or tungsten or quartz lighting equipment, you will get your money's worth from it by learning to use one light effectively. You will also better understand lighting, and learn to "see" good lighting by mastering a single light.

Watch the Eyes. When working with a single light, be certain that it illuminates both of your subject's eyes. To do this, it should be positioned slightly above and to the side of your subject (not too high or too far to the subject's side). This will produce a shadow on one side of the nose. With the light properly positioned, you will be able to

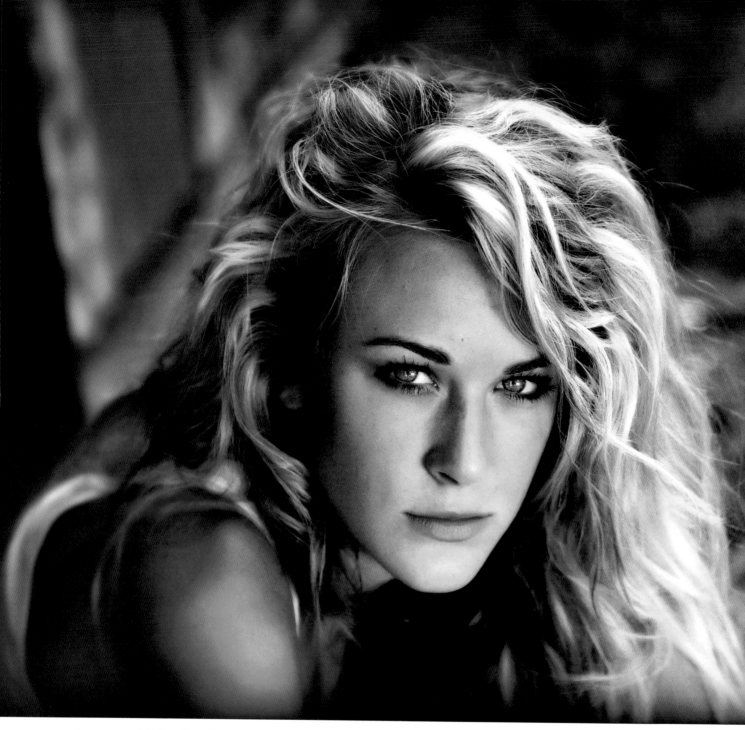

observe catchlights (small pure white specular highlights) in your subject's eyes at approximately 1 o'clock or 11 o'clock, depending on which side of the subject your light is positioned.

Try a Softbox. What is the perfect light source for one-light portraits? Hands down, the most flexible lighting tool in any photographer's lighting arsenal is the softbox. Little ones (24-inches square) are ideal for close-up portraits and are portable enough to use outdoors and on location. Large softboxes, up to seven feet tall, will literally paint your subject with soft, plentiful light, indoors or out. The degree of softness is dictated by the size of the light and the closeness to the subject.

Because softboxes are so flexible, they are easy to use, but require practice to master. The art of feathering the softbox needs to be acquired so that the dynamic portion

Here is another Tim Schooler shot of the same girl as on the previous page. This time the image was made outdoors with a smaller softbox and a large reflector fill to lower the lighting ratio a bit. Tim used natural sunlight as a hair light to add lustrous highlights to her beautiful hair.

of the light is in play. Directly aimed at the subject, a softbox can produce hot spots and burned out highlights—just like any other light. (*Note:* The perfect simple-lighting companion to the softbox is a reflector that can be used to augment the key light.)

Feathering the Light

One way to enhance the illusion of depth and quality in a portrait is to look for highlight brilliance—highlights with minute specular highlights within the main highlight.

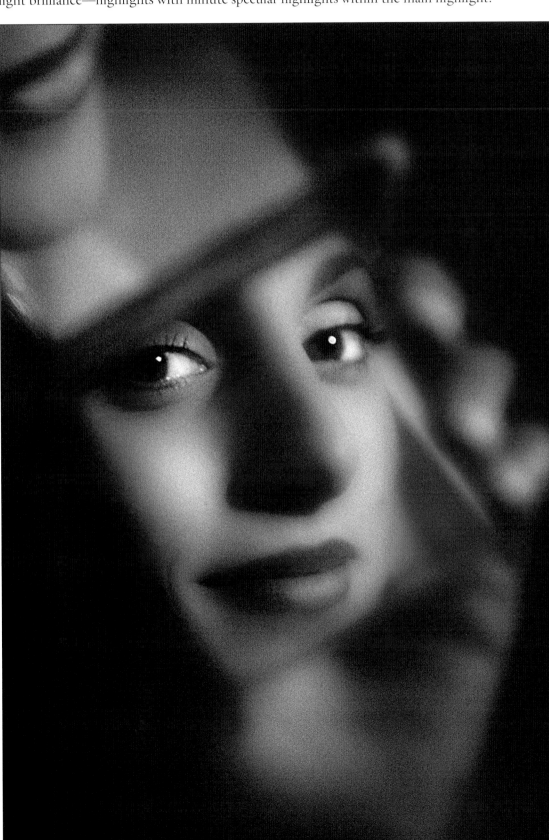

Yervant uses Lowel 55W and 100W handheld video lights called the I-light. Lowel also makes a dimmable ID-light, but dimming causes the white balance to fluctuate all over the place. In this image, made by photographing the bride's reflection in her makeup mirror, the light was feathered delicately by an assistant so that it was crisp and dynamic.

Feathering the light is a good way to attain this good lighting and enhanced highlight brilliance. To feather a light, instead of aiming it directly at the subject, adjust it so that the light shines past the subject. Essentially, this means that you are employing more of the edge of the light (rather than the very intense center) to illuminate your subject. (*Note:* When feathering a light, it is best to have an assistant position the light as you must judge the effect of the light from the camera position.)

Whether you are using raw or diffused light, use of the feathered edge of the light is almost always recommended. The central core of a light source is often unforgiving, while the dynamic edge yields spectacular results. (*Note:* The only exception is when using a very small source. In this case, feathering the light will sometimes cause the level of light to drop off appreciably with no noticeable increase in highlight brilliance. In these cases, it is better to make a slight lateral adjustment of the light—always checking the effect in the viewfinder.)

Diffusing the Main Light

Most contemporary portrait photographers, although they may have been trained to use parabolic lighting, now prefer to use diffused light sources for their key lights. Hair

Greg Phelps created this wonderful portrait of, Sonny Duncan, long-time coach and scout for USA Junior Olympics boxing. The lighting consisted of a medium Mola beauty light as the main light with a Chimera 4x6-foot softbox directly behind it set at one stop less brightness. Both lights were to the left of camera with the Mola in a high position and the Chimera at eye level. Behind and on either side were Chimera Strip lights for accent. There was a light on the background on the left fading a little darker to the right. No reflectors were used. One of the key aspects of this portrait is the elegant highlight specularity throughout the highlights on Sonny's face.

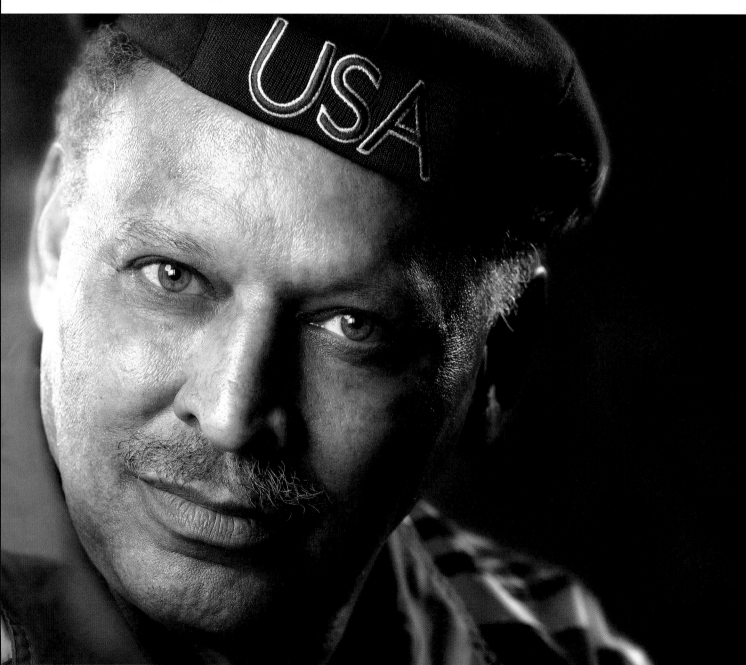

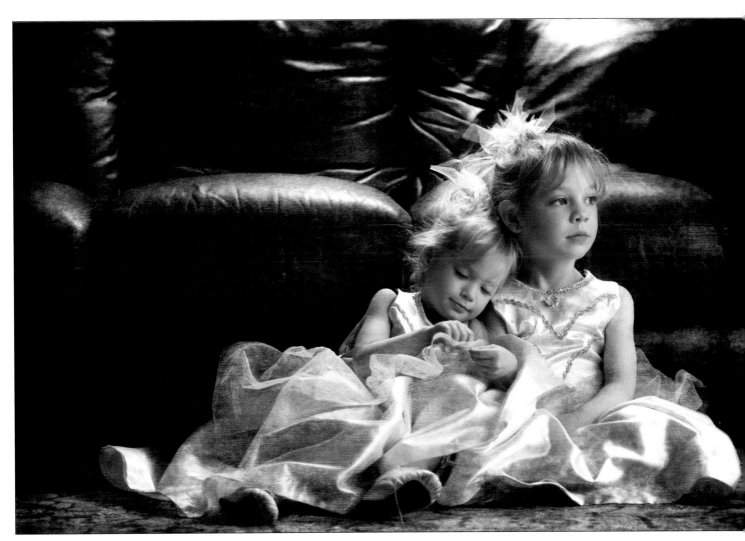

Bruce Dorn was commissioned to produce a portrait of two dancers similar to one his client had seen. He set up a leather couch with a big strip light above the back of the couch, and soft light designed to look like window light coming in from the right. He attached two Canon Speedlite EX 580 flash units to Strobe Slippers (precision-machined baseplates designed to connect a Canon Speedlite to a PocketWizard) to provide key light from the side. The speedlight rigs were mounted in small softboxes to soften the light. Bruce and the mother got the two girls in place, but they soon tired of modeling on the sofa. "The setup decayed into chaos," Dorn admits. "They tumbled down to the floor, bushed, and fell into this pose." With a mixture of stealth and speed, Bruce quickly adjusted the lights for this new pose, and started shooting. The image was made with a Canon EOS 1D Mark II with an 85mm f/1.2L USM lens.

lights and kickers are often diffused, as well. In these functions, strip lights and similar devices are commonly used to produce long, soft highlights in hair, on the edge of clothes, and on the background. The soft lighting emulates styles seen in the fashion world, which uses soft light as a rule.

The overall aesthetic of using soft light is not only seen to be more contemporary, but it is a lot easier to master from the photographer's point of view. Big soft light sources are inherently forgiving and since the lighting basically wraps the subject in soft light, retouching is minimized. Also, the transfer edge (see page 22) is much more gradual than with undiffused lights.

In the studio, soft lighting is often provided by huge soft boxes and other large light sources (see page 86 for one example). For location shoots, an ideal light diffuser is a

Here is a fabulous high-key image by Larry Peters. The high-school senior is in a swimming pool and Larry's lights are set up at the pool's edge, and a white background is flooded with light. You can see that over the camera are two large horizontally oriented scrims with strobes behind them. This creates a wall of soft light. Beneath the camera are overlapping reflectors (see close-up of her eyes, which reflect the main lights). The exposure was biased toward overexposure and Peters used a custom camera profile he created called Canon EOS Mark II Saturated. A 100mm lens helped get some distance between Larry and his subject.

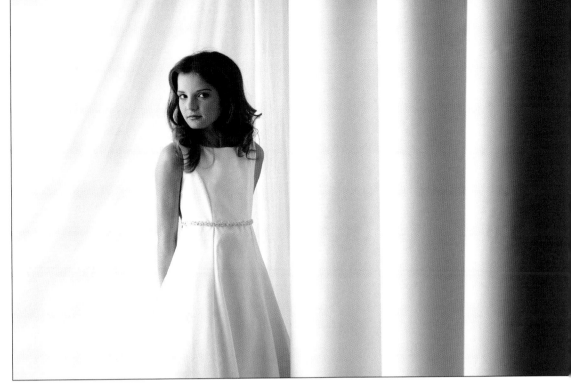

Here is an unusual high-key setup by Claude Jodoin. Instead of blasting the white background with light, he lit the scene from the side using a large 8x8-foot scrim with a single diffused White Lightning strobe. To simplify focusing, Claude used two additional undiffused daylight balanced hot lights on a camera stand with barn doors in standard 9-inch reflectors. These acted as his modeling lights, since the scrim and diffused strobe made the lighting on the set rather dim. Note, too, that a silver reflector was used opposite the key light to kick extra light into the scene and keep the lighting ratio on the high-key side.

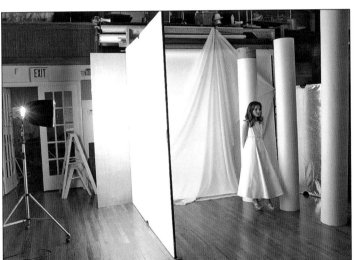

small (in the area of 24-inches square) softbox. You can move it in close to your subject for "big light" effects (the closer a diffused light source is to the subject, the softer the lighting becomes). A light source of this size used up close to the subject allows you to concentrate the light on the subject's face. It also falls off gradually toward the bottom of the frame, which is the effect you are seeking—after all, you don't want more light on the hands than on the face of your subject. The strobe inside the softbox should be fitted with a wide-angle parabolic reflector. This will optimize the quantity of light, focusing it on the forward panel of the softbox.

High-Key Lighting

There are a number of ways to produce high-key portrait lighting, but all require that you overlight your background by 1½ to 2 stops. For instance, if the main subject lighting is set to f/8, the background lights should be set at f/11 to f/16. Sometimes photographers use two undiffused light sources in reflectors at 45-degree angles to the

background, feathering the lights (angling them) so that they overlap and spread light evenly across the background. Other setups call for the background lights to be bounced off the ceiling onto the background. In either case, they should be brighter than the frontal lighting so that the background goes pure white. Because light is being reflected off a white background back toward the lens, it is a good idea to use a lens shade to minimize flare, which will often occur in high-key setups.

Low-Key Lighting

Low-key lighting is the opposite of high-key lighting. It uses strong lighting ratios and lots of dramatic dark tones created by using little or no fill and a sharp-edged or weak key light. Sometimes grid lights are used (grids narrow the light by channeling it down through small honeycomb openings in the light baffle). Window light can also be an effective low-key light source if used without a fill. Sometimes a black gobo is used opposite the key light to further deepen the shadows. Low-key lighting is often used to slim the appearance of large-figured people, since it is relatively easy to "hide" major portions of the person's body in blackness.

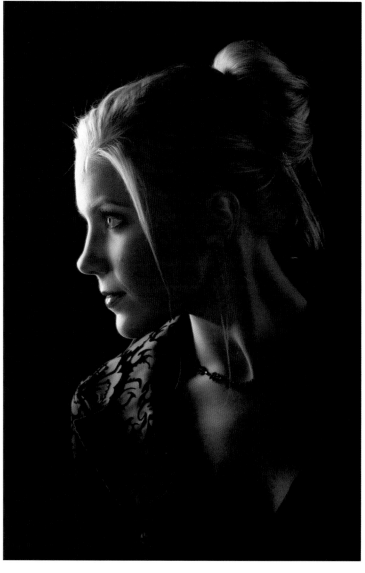

Here is a beautiful low-key lighting arrangement by Claude Jodoin. Behind the model, and feathered almost away from her, was a 24x30-inch softbox. It was fired into two reflectors, a 4x6-foot silvered reflector covered by a 4x6-foot translucent scrim. The latter was positioned over the hotter silver reflector to blend the bounce light and not overdo the specular highlights. Behind the model was a black bar with a silver reflector clamped to it to fill her shoulders and hair, so that—even though the setup is low key—there is detail throughout in the blacks. This is essentially a one-light setup but with great sophistication.

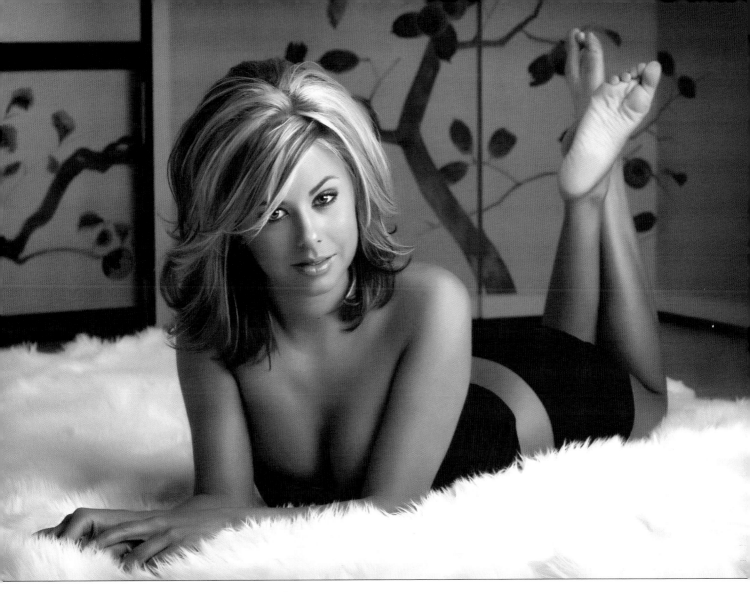

Kevin Jairaj made this lovely glamour portrait by using two scrims with strobes behind them. The scrims were side by side to camera right and the lights were powered down so that the output would be about one stop greater than the ambient room light. The result is a nice blend of the two light sources.

Dragging the Shutter

When you use a softbox and reflector as your main lighting tools for a location portrait, you can sometimes incorporate the ambient light from the room into the portrait for an integrated natural effect. The way this is done by matching the the flash exposure and the ambient-light exposure.

Begin by taking an incident reading of the light in the room. For example, let's imagine that the exposure from a combination of room light and window light is ¹⁄₃₀ second at f/4 at ISO 320. If you set up your softbox to fire at the flash-sync speed at f/8, you will overpower the background light completely and the image will look like it was taken in a dark, unlit room. However, if you match your shutter speed to the ambient light exposure (¹⁄₃₀ second) and power down your strobe to create an f/4 output, you will precisely blend the two light intensities. If you want the portrait part of the scene a little brighter than the background, which is often the case, set your strobe to produce an output of between f/4 and f/5.6, which will slightly overpower the ambient light.

6. The Pros' Favorite Techniques

Charles Maring: Three Tools for Simplified Lighting

Profoto Giant. Chuck Maring's favorite lighting setup this season is a Profoto Giant—a 7-foot reflector lit with a Profoto Acute 2400R for indoor work or a Profoto Acute 2BR for outdoor shooting. The reflector itself is a huge silvered umbrella with a preset frame that optimizes the light head position within the reflector. Maring says of this setup, "I have been trying to achieve results like this for years. As soon as I took my first shot, I knew the world was about to change. Lined in silver, the reflector offers specular, sharp lines, yet its sheer size yields soft natural light. It is the closest thing to daylight I have experienced. Depending on where the subject stands in the light, it offers endless opportunities." An image created with this light appears on the facing page.

Beauty Dish. Maring also loves the Profoto Soft White beauty dish with the 25-degree honeycomb grid. This can be powered with a Profoto Acute system or a Profoto Compact 600. "Beauty dish lighting is stunning," he says. "It offers heavy contrast with the smoothest transitions I've ever seen from highlight to shadow. What I love about both of these lights is that the quality of the modeling lamp and shaping tool make them WYSIWYG (what you see is what you get) when you fire the flash. This was completely different than working with softboxes, where you really couldn't see the results pre-shutter release."

The white beauty dish gives a soft, yet easily focused light. Meant to provide character lighting in portrait photography, the dish is superb for a wide variety of uses. From product to fashion photography, the softlight reflector is an excellent light source whenever a soft yet directional light is preferred. It is a distinctive alternative to an ordinary softbox. When used with a honeycomb grid you get a soft, toned-down edge-lighting effect.

Ring Flash. Maring is also a fan of the Profoto Acute Ring Flash—a direct-from-camera flash that is incredible for close-ups or outdoor fashion shooting. The Acute Ring Flash yields high-intensity specular qualities that gives images a very three-dimensional quality.

A ringflash is a strobe that surrounds the lens. Smaller, macro versions have circular flash tubes that form a 360-degree circle of light around the lens. These are very

ABOVE AND FACING PAGE—In this portrait, Charles Maring used the Profoto Soft White beauty dish set approximately 45 degrees to the left of the subject with a 25-degree honeycomb grid. A light blue sheer was used for a background and it was lit with a pink gel on a Profoto Compact 600 with barndoors. A hair light was used from above with a small Profoto strip light.

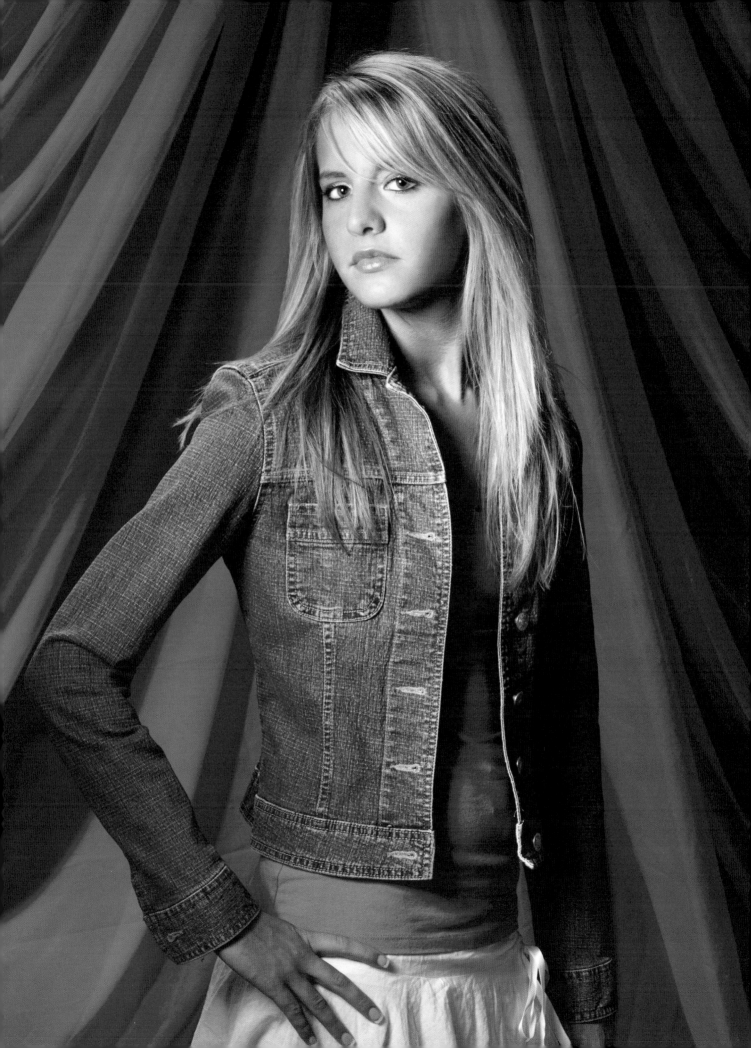

ABOVE AND FACING PAGE—*The Pro-foto Acute Ring Flash is a powerful circular light that yields high-intensity specular qualities and can be used for fashion lighting or portraiture. The light is also highly effective outdoors or on location.*

powerful and produce an on-axis, shadowless light that is frequently used by fashion photographers, as well as scientific and technical photographers. Ringflash is characterized by round, doughnut-shaped catchlights in the eyes.

A larger form of studio ringflash, or ringlight, places more than one light in a large pan dish with a hole in the middle, through which you position the lens and camera. Sometimes up to four lights are included in a ringlight and the light itself might be as wide as 25 inches in diameter. There are both strobe and hot ringlights available commercially, and they are used for everything from portraiture to fashion and glamour photography.

Fuzzy Duenkel: One-, Two-, and Three-Light Setups

Fuzzy Duenkel is well known for his sophisticated senior portraits. While he transports his studio-lighting setups to make stunning portraits in the subject's home, these techniques are equally applicable to studio shoots. As you'll see, Fuzzy's lighting technique differs significantly from the traditional portrait lighting setups described above, yet there are similarities. He uses one key light with ample fill. He also uses a background light and kickers (what he calls "edge lights") to illuminate the perimeter of his subjects. The following descriptions cover three of his more frequently used setups, employing one, two, and three lights, respectively.

One-Light Setup. Fuzzy's one-light setup uses a single key light, a 5x7-foot softbox set at about chin height and forward of the subject.

A large 6x6-foot silver reflector is the only fill, and it is used close to the subject. A homemade Mylar mirror reflector is used to redirect light from the key light back onto the subject. Fuzzy calls this an edge light because it illuminates the side or hair or torso of the subject, depending on where it is aimed.

LEFT—*Fuzzy Duenkel's lighting when viewed close up is exquisite and flawless. Soft, flattering light is his specialty, but he knows how to use it to sculpt a face to perfection.* BELOW—*Fuzzy Duenkel's one-light setup.*

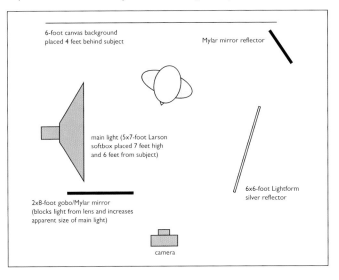

6-foot canvas background placed 4 feet behind subject

Mylar mirror reflector

main light (5x7-foot Larson softbox placed 7 feet high and 6 feet from subject)

6x6-foot Lightform silver reflector

2x8-foot gobo/Mylar mirror (blocks light from lens and increases apparent size of main light)

camera

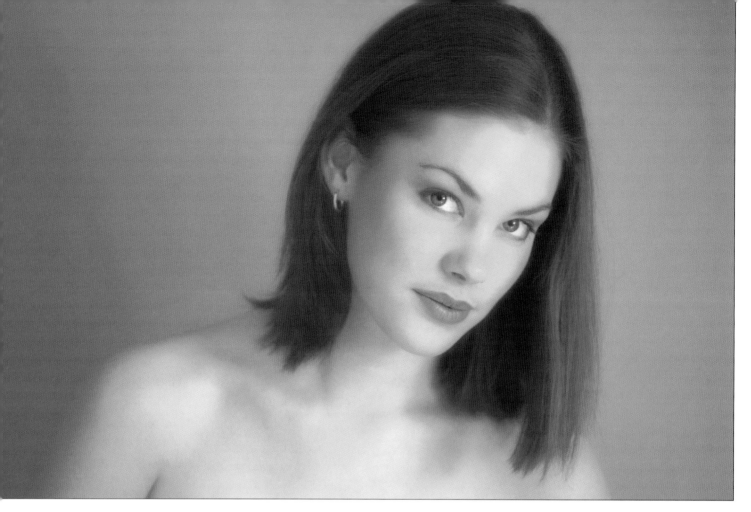

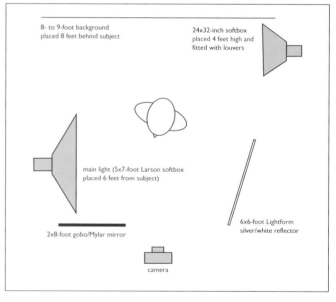

ABOVE—In Duenkel's two-light setup, the large softbox is used close to the subject and the frontal reflector. This gobos the camera and lens, and broadens the light for a large, elegant diffuse highlight. The background is lit mostly from spill from the main light and reflector. *RIGHT*—Fuzzy Duenkel's two-light setup.

8- to 9-foot background placed 8 feet behind subject

24x32-inch softbox placed 4 feet high and fitted with louvers

main light (5x7-foot Larson softbox placed 6 feet from subject)

2x8-foot gobo/Mylar mirror

6x6-foot Lightform silver/white reflector

camera

One other interesting feature of this setup is that a large gobo (2x8-feet) is used to block light from hitting the camera, which could cause lens flare. The opposite side of the gobo is mirrored Mylar to increase the relative size of the key light. You will notice that the canvas background is not lit separately. It is pulling light from the key light and reflector and is only positioned four feet from the subject, as seen in the diagram on page 89. You will see, in subsequent setups, that the larger and farther the background is from the subject, the more it needs its own light source.

Two-Light Setup. The same 5x7-foot softbox and 6x6-foot silver reflector are used as in the one-light setup, as is the mirrored gobo, which is used to minimize flare and expand the key light's apparent size.

Note that, in the diagram (above), the subject is eight feet from the background, which is farther than in the first example. Thus, a 24x32-inch Chimera softbox is used to light the background and produce an edge light on the subject. The light can be

feathered toward the background for more emphasis, or it can be feathered toward the subject for stronger edge light. The removable louvers control the amount of edge light and also prevent stray light from causing flare. An optional gobo may be used between the background light and subject to control the amount of edge light and shield the camera from stray light, which might cause flare. The gobo is used in case you want to remove the louvers from the softbox for more light on the subject and less feathered light on the background.

"The removable louvers control the amount of edge light and also prevent stray light from causing flare."

It is important to control the difference in output between the key light and the background light. Fuzzy aims for f/11 from the key light, then sets the background light to produce f/8 for low-key backgrounds, or f/16 for high-key backgrounds.

Three-Light Setup. The main difference with this setup is that a second background light is used to add double-edged lighting on the subject (or for high-key backgrounds). You will note in the diagram (below) that a hinged reflector is used very close to the subject, just out of view of the camera. This reflector, like so many of Fuzzy's lighting accessories, is homemade from insulation boards and is white on one side and silver on the other. The other part of the reflector is being used as a gobo to keep stray light from hitting the camera lens.

As with the other lighting setups, the key light is positioned just under chin height. This keeps light in the eyes and helps avoid what Fuzzy calls "dark eye bags." It should be noted that while softboxes are used as a key light in all three setups, a flash bounced into a white wall may be

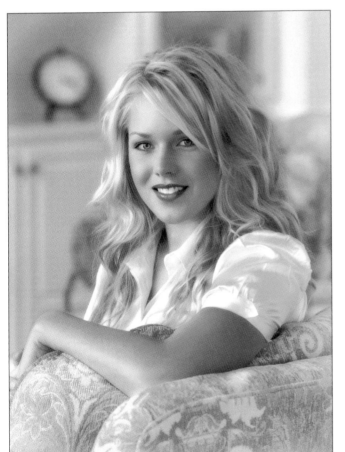

LEFT—Whether Fuzzy Duenkel uses one, two or three lights, the effect is the same—a big soft key with strong fill-in from the hinged 4x8-foot reflector and good lighting in the background. This image used two smaller softboxes for the background as in the three-light setup. **BELOW**—Fuzzy Duenkel's three-light setup.

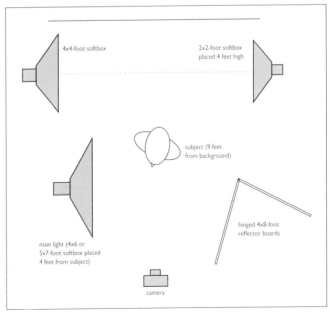

4x4-foot softbox

2x2-foot softbox placed 4 feet high

subject (9 feet from background)

hinged 4x8-foot reflector boards

main light (4x6 or 5x7-foot softbox placed 4 feet from subject)

camera

used in tight quarters. Fuzzy normally uses an f/8 setting for the key light with a background light setting between f/5.6 and f/8. In all three lighting setups, Fuzzy also recommends adjusting the fill reflector by eye.

The above information is from Fuzzy Duenkel's CD, entitled *Fuzzy Logic*, which is available from his web site: www.duenkel.com.

Monte Zucker: Success with Scrims

Acclaimed wedding and portrait photographer Monte Zucker perfected a system of using large scrims—3x6 feet and up. With the sun as a backlight, he had two assistants hold the translucent light panel above and behind the subject so that the backlighting was diffused. He paired this with a reflector placed close in front of the subject to bounce the diffused backlight onto the subject. The effect is very much like an oversized softbox used close to the subject for shadowless lighting.

Beth Forester: Simplified Softbox Lighting

According to senior-portrait specialist, Beth Forester, "When shooting seniors, I am always rushing trying to get a lot of images made in a short period of time, there-

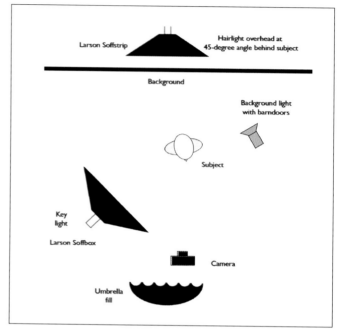

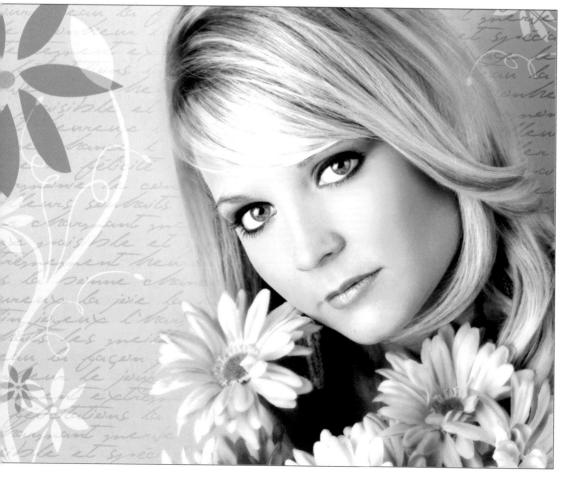

ABOVE AND LEFT—Here, Beth Forester used a background with a softbox key and umbrella fill, both of which you can see mirrored in the catchlights of the the girl's eyes. She also used a PhotoDuds template of her own design, including flowers and French script.

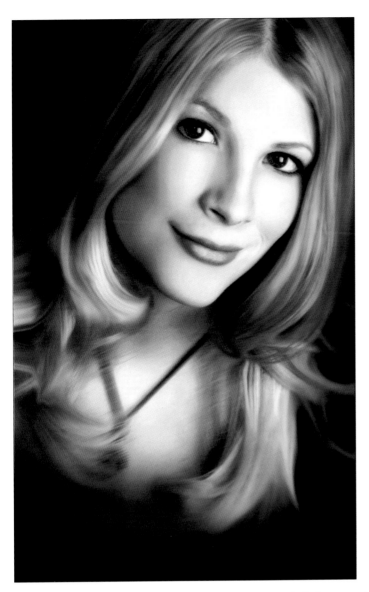

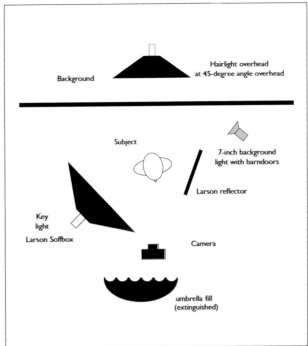

Background

Hairlight overhead at 45-degree angle overhead

Subject

7-inch background light with barndoors

Larson reflector

Key light

Larson Soffbox

Camera

umbrella fill (extinguished)

ABOVE AND LEFT—In this image, the lighting was the same as in the previous shot, but the umbrella fill was extinguished to provide more of a lighting ratio. A reflector was also added to camera right. Beth Forester uses basically the same lighting pattern for everything she does with seniors. This simplification allows her to accomplish a great deal in a short period of time.

fore, I like to keep my lighting simple and easy. Ninety percent of the time I use four different lighting setups. All of the key lights are the same—a Photogenic Powerlight with a 3x4-foot Larson Soffbox; the reflector is a Larson 3x5-foot model (or sometimes an umbrella fill light); the background light is a Photogenic Powerlight with barndoors, and the hair light is another Photogenic with a Larson Strip Soffbox."

With a Background. "When I am shooting with a background," says Beth, "I use a softbox key light, umbrella fill light, a Larson Strip Soffbox hair light and a background light for separation. I shoot at f/8 and meter the fill at between f/4 and f/5.6. The same goes for the hair light; however, the hair light is fastened to the ceiling and I do not change the output at all. So, if the person is standing they will get a stronger hair light; sitting on the ground, they'd receive less hair light, as you'd expect. Since I try not to do a lot of intricate lighting set-ups, this just helps to add a little variation. The background light is set to what I think looks best through the camera (a little stronger for darker backgrounds, a little less for lighter shades)."

For a Little More Drama. For a different, more dramatic effect when shooting on a background, Beth creates a higher lighting ratio by switching her fill-light source. "I will turn off the umbrella fill and simply use a reflector for the fill," she says. "The hair light and background light are set the same as above."

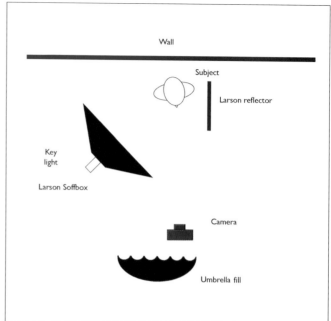

ABOVE AND LEFT—In this image, Beth photographed her subject against a wall with the above lighting setup and incorporated PhotoDuds later in Photoshop. PhotoDuds is Beth Forester's unique template system that the seniors call "tattoos," a signature template including writing or graffiti or in this case a reduced opacity portrait of the same senior and French sayings as part of the background.

Leaning on a Wall. "All of my walls have sets either constructed on them or painted on them," says Beth. "Therefore, I shoot a lot of subjects leaning against a wall. In these, setups I am unable to use a hair light because I do not have track lighting and I have a lot of walls. Some sets are only 4-feet wide and some are 5-, 6-, or 8-feet wide—some are even constructed in corners. I try to use every available bit of space I can. In these set-ups I use a key light, a fill with an umbrella, and a reflector."

Claude Jodoin: Today's Glamour Lighting

Traditionally, glamour lighting has been done with the main light placed directly over the subject, then aimed down to create a distinct butterfly-shaped shadow under the nose. This is not a "corrective" way to light a face. It is used to emphasize faces that have a symmetrical structure—faces found primarily on those rare creatures we call "professional models." Until the introduction of color films and 16- to 20-inch parabolic flash sources in the 1950s, Hollywood photographers like George Hurrell also lit their movie-star subjects in this manner, pairing tungsten spotlights with 8x10 black & white film. For this reason, this lighting pattern is also known as Paramount lighting.

Today's typical glamour headshots are done on digital cameras in color with soft flash sources of various sizes, so the butterfly pattern is not as obvious as it was in the old days of small main lights. Today, it mostly refers to the 12 o'clock catchlight created by the larger sources of illumination. By using one or more silver or white reflec-

tors beneath the chin of the model, we create a second catch light at 6 o'clock position. This type of lighting is very useful for model headshots. This central placement allows for facial and body movements left to right, from full face to two-thirds view, creating a modified butterfly pattern, while working on various expressions that define the subject's personality. Varying the size of the light source changes the shadow edge transfer characteristic to help shape the nose and cheekbones. This gives us very little corrective control as compared to other classic lighting patterns and positions, so, as a rule (which can be broken), we should reserve this mostly for photogenic subjects.

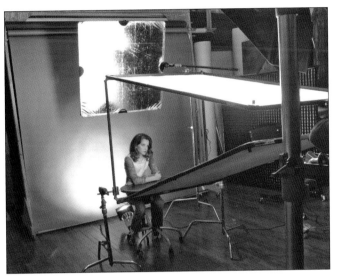

David Williams and Yervant Zanazanian: Handheld Video Lights

Australian photographers David Williams and Yervant Zanazanian use small handheld video lights to augment existing light while on location. Yervant uses Lowel I-

Both glamour shots below were made with the setup that Claude Jodoin calls the "glamour wedge" (left). This involves a light aimed down to fill a 3½x6-foot diffuser and a silver reflector of the same size placed below the subject to kick up the fill at about 60 percent of the diffused key-light intensity. It's like shooting through a tunnel of soft light. Behind the model is a 3x3-foot silver reflector that kicks light back on the subject's hair, acting as a hair light. Behind both subjects and in the setup shot, you can see a background light placed below the height of the model, which lights the background. The subject of the photograph on the right is Crystal Hayes, Miss Michigan USA, 2005.

and ld-lights, which are powerful, battery-powered, handheld video lights that use either 55W or 100W filaments. They are ideal to handhold or have an assistant hold because they produce plenty of light and the light source itself is easily feathered so that you are constantly using the dynamic edge of the sharp-edged light.

Williams has glued a Cokin Filter holder to the front of his video light (a 20W model) and places a medium blue filter (a 025 Cokin) in the holder. The filter brings the white balance back from tungsten to about 4500K, which is still slightly warmer than daylight. It is the perfect warm fill light. If you want an even warmer effect, or if you are shooting indoors with tungsten lights, you can simply remove the filter.

These lights sometimes have variable power settings. Used close to the subject (within 10 feet) they are fairly bright, but can be bounced or feathered to cut the intensity. Williams often uses them when shooting wide open, so they are usually used just for fill or accent.

The video light can also be used to provide what Williams calls, a "kiss" of light. He holds the light above and to the side of the subject and feathers it back and forth while looking through the viewfinder. The idea is to produce just a little warmth and light on a backlighted object or a subject who is lit nondescriptly.

Sometimes he uses an assistant to hold two lights, each canceling out the shadows from the other. He often combines these in a flash-bracket arrangement with a handle. His video light has a palm grip attached to the bottom to make it more maneuverable when he has the camera in the other hand.

Fuzzy Duenkel: Garage Light

Not long ago, photographer Fuzzy Duenkel started photographing seniors in their home garages. This is a location one would not expect to work well, but Fuzzy is adept

In a darkened pub, Yervant Zanazanian used a handheld video light (held by an assistant) to light this dazzling portrait. The key is balancing the room lights with the video light, which is pretty easy to do by either increasing or decreasing the power or distance to the subject of the video light or feathering the light.

Below are two examples of senior portraits done by Fuzzy Duenkel with garage light. Fuzzy is harnessing only available light, but because he uses such high-efficiency reflectors as his homemade Mylar FuzzyFlector, the light looks like studio lighting. Refer to the accompanying diagrams and see if you can follow the path of the main light source(s).

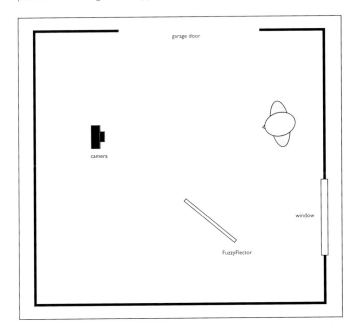

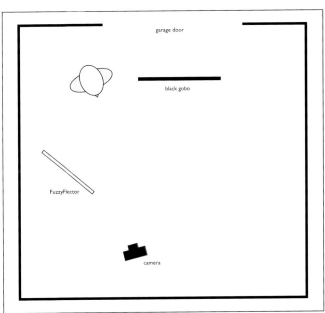

at harnessing directional light and turning it into elegant portrait light. Fuzzy's senior portraits, which he does primarily on location at their homes, are rich with content. The garage is a museum of family heirlooms.

There are a couple of scenarios he uses. With a large open garage door, he gobos off much of the incoming light to prevent flare. Positioning the subject out of the way of the backlight, he uses a Mylar reflector to create a key light, harnessing the edge of the incoming available light.

In another garage-light scenario, he uses a small garage window as an edge light and positions his subject to take advantage of the powerful backlighting. He positions his subject out of the way of the direct light coming from the open garage door and sets up a Mylar reflector to produce strong side lighting.

Fuzzy Duenkel is a master at twisting and bending shade, transforming it into golden, soft, sculpting light (more on this in the next chapter). He uses a number of large, highly efficient reflectors to redirect the shade and create a flattering lighting pattern. Here a large, gold-foil reflector was positioned close to the left side of the subject, which became the highlight side of her face. The shadow side was filled in using smaller reflectors. Fuzzy also blended the highlights and shadows of the image in Photoshop.

7. Outdoor Lighting Techniques

Cherie Steinberg Coté created this high-fashion image with a Dyna-Lite Jackrabbit kit. Cherie says, "It was sunset and the sky was perfect. With the two Dyna-Lite strobes, we popped the model. The second flash was feathering the helicopter."

If you can see and predict the usefulness of light in the studio, then consider expanding your studio skills to the great outdoors, where natural beauty abounds and adds an authenticity to portraits.

Nature provides every lighting variation imaginable. That's why so many images are made with it. Often, the light is so good that there is just no improving on it. For example, I used to work for a major West Coast publishing company that specialized in automotive publications. One of the studios that was used for photographing cars was

massive, with a ceiling that was between three and four stories high. Below the ceiling was a giant scrim suspended on cables so that each of the four corners could be lowered or raised. Huge banks of incandescent lights (twelve and sixteen lights to a bank) were bounced into the scrim to produce a huge milky-white highlight the length of the car—a trademark of automotive photography. The studio was used when a car could not be photographed outside in public or when it was only on loan to the magazine

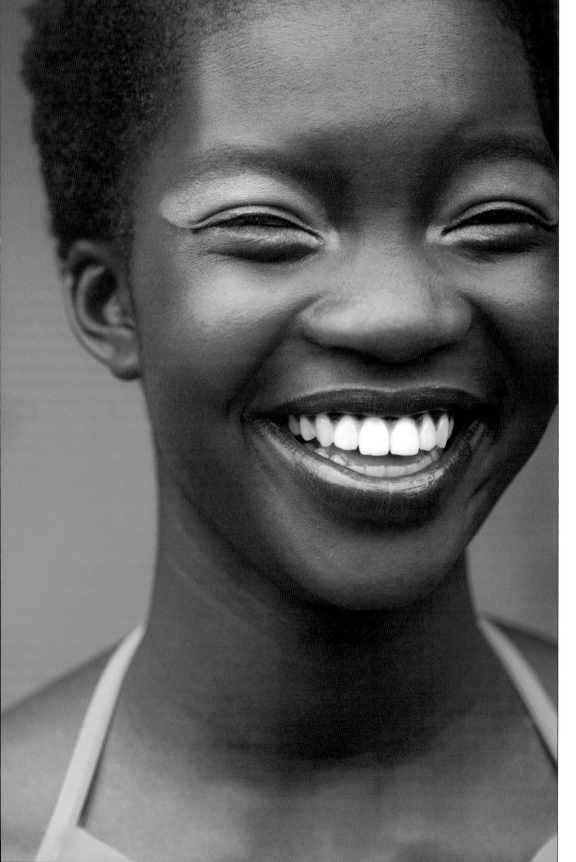

LEFT—Open shade can be extremely directional. Michael Costa used the open shade's overhead nature to highlight the bone structure of this beautiful young girl. Notice where the highlights fall—on her cheekbones, forehead and the bridge of the nose. Because of her wild eye makeup and lipstick, the overhead lighting is not the negative it might otherwise be. No fill was used here.

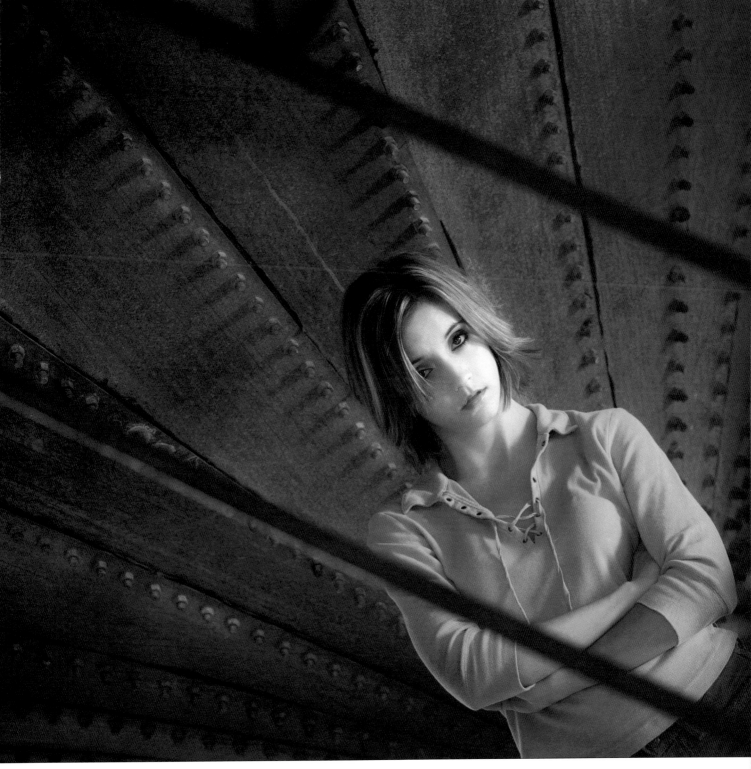

ABOVE—This senior portrait was shot on the shadow side of a grain bin. A 72-inch silver reflector was placed about thirty feet to the right of subject to redirect light onto her face. A second small reflector was placed to the left of the subject to brighten the shadows. Note the edge light the second reflector created along the subject's right arm and shoulder. Photograph by Craig Kienast.

(*Motor Trend*) for a very short time. Despite the availability of this space, if time and the weather were on their side, the staff photographers would invariably opt to photograph the car at twilight, when the setting sun, minutes after sunset, created a massive skylight in the Western sky. No matter how big or well equipped the studio, nature's light is far superior in both quantity and quality.

Finding the Right Light

Shade. In order to harness the power of natural light, one must be aware of its various personalities. Unlike the studio, where you can set the lights to obtain any effect

you want, in nature you must use the light that you find or alter it to suit your needs. By far the best place to make outdoor images is in the shade, away from direct sunlight.

Shade is nothing more than diffused sunlight. Contrary to popular belief, shade is not directionless. It has a very definite direction. The best shade for any photographic subject, but primarily for people, is found in or near a clearing in the woods. Where the trees provide an

Jeff Smith does not find it difficult to work at mid-day. For example, in this image he found a nice clearing, just on the edge of a sunlit meadow in the middle of the day. He used the shade as his base exposure and added a large battery-powered softbox as the key light. As you can see, the softbox created an elegant lighting pattern and overpowered the shade exposure by about half a stop.

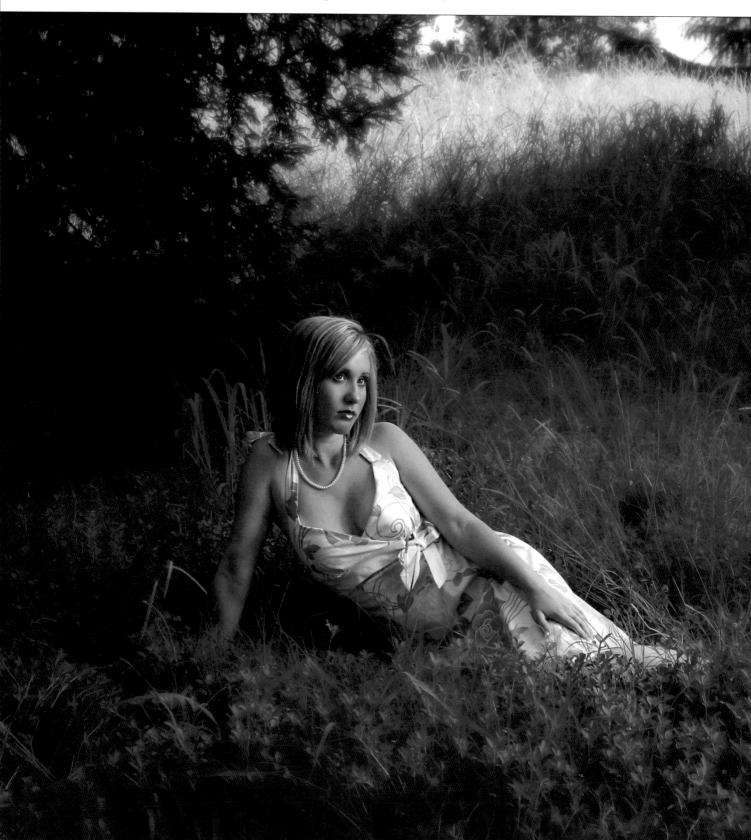

overhang above the subjects, the light is blocked. From the clearing, diffused light filters in from the sides, producing better modeling on the face than in open shade. (Open shade is overhead in nature and most unflattering. Like noontime sun, it leaves deep shadows in the eye sockets and under the nose and chin of the subjects. If forced to shoot in open shade, you must fill-in the daylight with a frontal flash or reflector.)

Another popular misconception about shade is that it is always soft. Particularly on overcast days, shade can be harsh, producing bright highlights and deep shadows, especially around midday. Instead, move under an overhang, such as a tree with low-hanging branches or a covered porch, and you will immediately notice that the light is less harsh and that it also has good direction. The quality of light will also be less overhead in nature, coming from the side that is not obscured by the overhang.

Working at Midday. For award-winning senior photographer Jeff Smith, working at midday has become an economic necessity. The best outdoor locations are thirty to forty minutes from his studio. To make it profitable to drive that far for a senior session, he schedules multiple sessions at the same location. He cannot afford the luxury of working only in the early morning or late afternoon when the light is best, so he schedules these appointments throughout the day.

Smith works in shade exclusively. He tries to find locations where the background has sunlight on dark foliage and where the difference between the background exposure and the subject exposure is not too great. At the subject position, he first looks for lighting direction. He always tries to find an area where there is something that is blocking the light from the open sky overhead—a tree branch, the roof of a porch, or a black reflector (which he brings along for such situations). If there is no lighting ratio on the face, he creates one using a black gobo on the shadow side of the face for a subtractive lighting effect (see page 30).

Once Jeff has the basic lighting the way he wants it, he adds a reflector beneath the subject, bringing out more eye color and smoothing the complexion, which is a must for seniors. He uses 72-inch Photoflex gold and white reflectors. He loops the handle of the reflector over a knob on his tripod and lets the bottom rest on the ground. This is the perfect angle for bouncing daylight up and into the face of his subject. In bright situations, he uses the white reflector to avoid overpowering the natural light. In very soft light, he uses the gold reflector.

After Sunset. As many of the great photographs in this book illustrate, the best time of day for making great pictures is just after the sun has set. At this time, the sky becomes a huge softbox and the effect of the lighting is soft and even, with no harsh shadows.

There are two problems with working with this great light. First, it's dim. You will need a medium to fast ISO combined with slow shutter speeds, which can be problematic if there are children being posed. Working in subdued light also restricts your depth of field by virtue of having to choose wider apertures.

The second problem in working with this light is that twilight does not produce catchlights—white specular highlights in the eyes of the subjects. For this reason, most photographers augment the twilight with flash, either barebulb or softbox-mounted, to provide a twinkle in the eye. The flash can be up to two stops less in intensity than the skylight and still produce good eye fill-in and bright catchlights.

WORKING AT MID-DAY—PHOTOSHOP'S SHADOW/HIGHLIGHT TOOL

E. J. Simpson, well known professional rodeo photographer says, "It's interesting that most photographers' favorite times to shoot are early morning and late afternoon for the golden light. With rodeos, it seems everything I do is mid-day in full sun, so I love using Photoshop's Shadow/Highlight tool. This tool has been a life-saver for my mid-day rodeo shooting."

To activate the Shadow/Highlight tool in Photoshop, go to Image > Adjustments > Shadow/Highlight. "It opens with the Shadows slider at 50 percent and the Highlights slider at 0," says Simpson. "I will then bring down the Shadows to 0 and start raising it to get the shadows lightened to an amount that gives me good shadow detail (usually a little more than I need, because I always boost the contrast afterwards to give the image a little pop and I don't want to block up the shadow areas). The amount for Shadows can be anywhere from 5 to 50 percent but usually in a range of 15 to 30 percent. Then, I will raise the Highlight slider from 0 to between 3 and 20 percent, depending on the look I want. I have found this to be a really easy and quick way to get great looking shots that were taken in the direct sunlight at around mid-day. It works well for my rodeo images where 95 percent of the people have cowboy hats on."

The Shadow/Highlight command is also suitable for correcting silhouetted images due to strong backlighting or correcting subjects that have been slightly washed out because they were too close to the camera flash. The adjustment is also useful for brightening areas of shadow in an otherwise well-lit image. The Shadow/Highlight command does not simply lighten or darken an image; it lightens or darkens based on the surrounding pixels in the shadows or highlights. For this reason, there are separate controls for the shadows and the highlights. The defaults are set to fix images with backlighting problems. The Shadow/Highlight command also has a Midtone Contrast slider, Black Clip option, and White Clip option for adjusting overall contrast. It's a valuable tool for mid-day lighting.

Because E. J. Simpson does most of his work in the middle of the day, he favors Photoshop's Shadow/Highlight tool for adjusting lighting contrast and color in the shadows, highlights, and midtones.

This is one of E. J. Simpson's favorite rodeo images from 2006. Notice how the deep shadows of the trees in the background have been opened up to lend a natural feeling to this image.

Controlling the Background

Depth of Field and Diffusion. For a portrait made in the shade, the best type of background is monochromatic. If the background is all the same color, the subjects will stand out from it. Problems arise when there are patches of sunlight in the background. These light patches can be minimized by shooting at wide apertures. The shallow depth

of field blurs the background so that light and dark tones merge. You can also use a diffuser over the camera lens to give your portrait an overall misty feeling. When you do so, you will also be minimizing a distracting background.

Retouching. Another way to minimize a distracting background is in retouching and printing. By burning-in or diffusing the background you make it darker, softer, or otherwise less noticeable. This technique is really simple in Photoshop, since it's fairly easy to select the subjects, invert the selection so that the background is selected, and perform all sorts of maneuvers on it—from diffusion and color correction to density correction. You can also add a transparent vignette of any color to visually subdue the background.

Subject-to-Background Distance. Some photographers, when working outdoors, prefer to place more space between group members to allow the background to become better integrated into the overall design.

Tonal Separation. One thing you must watch for outdoors is subject separation from the background. A dark-haired subject against a dark-green forest background will not separate, creating a tonal merger. Adding a background reflector to kick some light onto the hair would be a logical solution to such a problem.

BRUCE DORN ON NATURAL LIGHT

Bruce Dorn urges photographers to observe the sun. "Notice how the sun, so hard and bright and very far away, manages to offer so much variation," he says. "Study how this singular source reflects off of things, the light rays bouncing about and picking up all manner of color casts en route. The convoluted textures and warm hues of a sandstone cliff becomes one sort of reflector while the cold, white side of a delivery truck creates quite another."

When clouds come in, they are merely new lighting tools, according to Dorn. "An overcast day comes in nearly infinite variations, each with a unique character and mood. A ceiling of cirrus clouds, which cinematographers call "High Silk," diffuses but simultaneously renders very distinct shadows. A heavier blanket of overcast also illuminates but can quickly become somewhat cold, directionless, and somber. What, exactly, is going on up there?"

"In the process of noticing the quality of light," says Dorn, "you will also come to appreciate the effects of the direction of light. As you observe and learn, try to separate the effects of each characteristic. Our ultimate goal is to mix and match both in the service of concept."

Bruce Dorn made this interesting portrait of two teens, allowing the power lines to intersect their heads—perhaps a statement about how tied in America's youth is to the Internet and other mass communications options. He used a Strobe Slipper, a device he manufactures, which is a softbox that holds one or more radio-controlled portable flash units. When the handheld softbox is held close by an assistant, it produces elegant location lighting.

Reflectors

You are at the mercy of nature when you are looking for a lighting location. Sometimes it is difficult to find the right type of light for your needs. Therefore, it is a good idea to carry along a portable light reflector. The size of the reflector should be fairly large; the larger it is, the more effective it will be. Portable Lite Discs, which are reflectors made of fabric mounted on a flexible and collapsible circular or rectangular frame, come

FACING PAGE—Here, Fuzzy Duenkel manipulated the light with reflectors (and later in Photoshop) to create a perfectly soft, sculpted effect. Then, he softened the background and enhanced the color to create a truly memorable portrait.

in a variety of diameters and are a very effective source of fill-in illumination. They are available from a number of manufacturers and come in silver (for maximum fill output), white, gold foil (for a warming fill light), and black (for subtractive effects).

Positioning. When the shadows produced by diffused light are harsh and deep, or even when you just want to add a little sparkle to the eyes of your subjects, you can use a large reflector—or even several reflectors. It helps to have an assistant (or several light stands with clamps) so that you can precisely set the reflectors. Be sure to position them outside the frame area.

You will have to adjust the reflector several times to create the right amount of fill-in, being sure to observe lighting effects from the camera position. Be careful about bouncing light in from beneath your subjects. Lighting coming from below the eye–nose axis is generally unflattering. Try to "focus" your reflectors (this really requires an assistant), so that you are only filling the shadows that need filling in.

With foil-type reflectors used close to the subjects, you can sometimes even over-power the ambient light, creating a pleasing and flattering lighting pattern.

Natural Reflectors. Many times nature provides its own fill-in light. Patches of sandy soil, light-colored shrubbery, or a nearby building may supply all the fill-in you'll

Would you believe this elegant lighting is all natural? It is—and it is how Fuzzy Duenkel likes to work. Soft backlight is enhanced by the use of a silvered reflector, making the light more directional and crisp. A reflector was used close to and beneath the subject's face to provide a beautiful lighting pattern. Selective focus was employed by use of a wide aperture and Gaussian blur in Photoshop to create a subtle mask of sharpness, which accentuates this young lady's elegant features.

need. Be careful, though that fill light directed upward from the ground onto your subject doesn't overpower the key light. Lighting coming from under the eye–nose axis is so unattractive that it's often called "ghoul light" (for obvious reasons).

Subtractive Lighting

Too-Diffuse Light. There are occasions when the light is so diffuse that it provides no modeling of the facial features. In other words, there is no dimension or direction to the light source. In these cases, you can place a black fill card (also called a gobo or flat) close to the subject to block light from reaching crucial areas. The effect of this is to subtract light from the side of the subject on which it's used, effectively creating a stronger lighting ratio. This difference in illumination will show depth and roundness better than will the flat overall light.

Another instance where black reflectors come in handy is when you have two equally strong light sources, each powerful enough to be the key light. This sometimes happens when using direct sun and a Mylar reflector. The black reflector used close to one side or the other of the subject will reduce the intensity of the lighting, providing a much-needed lighting ratio.

Overhead Light. If you find a nice location for your portrait but the light is too overhead (creating dark eye sockets and unpleasant shadows under the nose and chin), you can use a gobo to block the overhead illumination. The light that strikes the subject then comes from either side and becomes the dominant light source. This lighting effect is like finding a porch or clearing to block the overhead light. There are two drawbacks to using an overhead gobo. First, you will need to have an assistant(s) along to hold the card in place over the subject. Second, using the overhead card lowers the overall light level, meaning that you may have to shoot at a slower shutter speed or wider lens aperture than anticipated.

EMPLOY A TRIPOD

If you are not using flash, you should use a tripod when shooting outdoor portraits. Shutter speeds will normally be on the slow side, especially when you are shooting in shade. Also a tripod helps you compose your portrait more carefully, and gives you the freedom to walk around the scene and adjust things as well as to converse freely with your subject. A tripod is also a handy device for positioning a reflector—the large ones often come with loops that can be attached to the legs or knobs of the tripod when you are working without an assistant.

Diffusion Screens

Spotty Light. If you find an ideal location, but the light filtering through trees is a mixture of direct and diffused light (*i.e.*, spotty light), you can use a diffusion screen or scrim held between the subject and the light source to provide directional but diffused lighting. Scrims are available commercially and come in sizes up to 6x8 feet. These devices are made of translucent material on a semi-rigid frame, so they need to be held by an assistant (or assistants) to be effectively used.

Direct Sunlight. Scrims are great when you want to photograph your subject in direct sunlight. Simply position the scrim between the light source and the subject to soften the available lighting. The closer the scrim is to the subject, the softer the lighting effect will be. As with window light, the Inverse Square Law (see page 19) applies to the light coming through a scrim. Light falls off fairly quickly once it passes through the scrim.

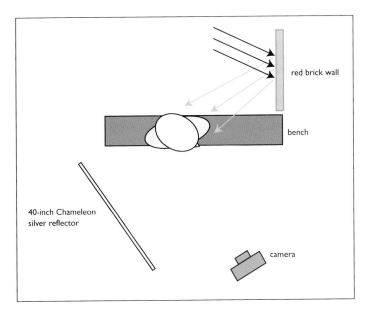

red brick wall

bench

40-inch Chameleon
silver reflector

camera

FACING PAGE AND ABOVE—This formal
portrait was made on location with
the light that was reflected from a
red and pink brick wall. The light,
being warm-toned, required no fil-
tration for color correction. A silver
reflector was used to fill in the side of
the face opposite the wall. Photo-
graph by Fran Reisner.

Backlighting. Another use for scrims is in combi-
nation with a reflector. With backlit subjects, the scrim
can be held above and behind the subjects and a sim-
ple reflector used as fill-in for soft outdoor lighting.
The soft backlight causes a highlight rim around the
subject, while the reflector, used close to the subject,
provides a low lighting ratio and beautiful soft, frontal
lighting.

Metering. Using a scrim will lower the amount of
light on the subject, so meter the scene with the de-
vice held in place. Since the light quantity will be
lower on your subject than the background and the
rest of the scene, the background may be somewhat
overexposed—not necessarily an unflattering effect.
To minimize the effect and prevent the background
from completely washing out, choose a dark-to-medium-colored background. This type
of diffusion works best with head-and-shoulders portraits, since the size of the diffuser
can be much smaller and held much closer to the subject.

Flash Techniques

X-Sync Speeds. All cameras with focal-plane shutters have an X-sync speed, the fastest
speed at which you can fire the camera with a strobe attached. At speeds faster than the
X-sync speed, only part of the frame will be exposed, because the moving shutter cur-
tain will block a portion of the frame. Modern SLRs and DSLRs have X-sync speeds
up to $\frac{1}{500}$ second. (*Note:* Cameras with lens shutters, on the other hand, will sync with
flash at any shutter speed.)

You can, of course, work at a shutter speed *slower* than the X-sync speed. This allows
you to incorporate available light into the scene along with the flash. There is no limit
to how slow a shutter speed you can use, but you may incur subject movement at very
slow shutter speeds. In these situations, the sharply rendered subject will have an un-
natural shadow around it, as if cut out from the background.

Fill Light. To measure and set the light output for a fill-in flash situation, begin by
metering the scene. It is best to use a handheld incident meter with the hemisphere
pointed at the camera from the subject position. In this hypothetical example, the me-
tered exposure is $\frac{1}{15}$ second at f/8. Now, with a flashmeter, meter the flash only. Your
goal is for the output to be one stop less than the ambient exposure. Adjust the flash
output or flash-to-subject distance until your flash reading is f/5.6. Set the camera to
$\frac{1}{15}$ second at f/8. If using digital, a test exposure is a good idea.

Barebulb Fill. One of the most frequently used handheld flash units is the barebulb
flash, which acts more like a large point source light than a small portable flash. Instead
of a reflector, these units use an upright flash tube sealed in a plastic housing for pro-
tection. Since there is no housing or reflector, barebulb flash provides 360-degree light
coverage, meaning that you can use it with all of your wide-angle lenses. However,
barebulb units produce a sharp, sparkly light, which is too harsh for almost every type
of photography except outdoor portraits.

Light falloff is less than with other handheld units, making barebulb ideal for flash-fill—particularly outdoors. The trick is not to overpower the daylight. In each of Bill McIntosh's outdoor portraits, for instance, he uses barebulb flash to either fill-in backlit subjects or to add a little punch to sunlit subjects when the sun is very low, early in the morning or at sunset.

Barebulb units are predominantly manual flash units, meaning that you must adjust their intensity by changing the flash-to-subject distance or by adjusting the output.

Softbox Fill. Other photographers like to soften their fill-flash. Robert Love, for example, uses a Lumedyne strobe in a 24-inch softbox. He triggers the strobe cordlessly with a radio remote control. He often uses his flash at a 45-degree angle to his subjects (for small groups) for a modeled fill-in. For larger groups, he uses the softbox next to the camera for more even coverage.

FACING PAGE—Kevin Jairaj photographed this couple with available light and fill flash. Light was coming from camera left and from behind camera. The skin tones are warm because Kevin set the white balance on his Canon 20D to cloudy. The flash, just noticeable, added a little fill and catchlights to the eyes. Kevin also shoots in RAW mode so that he can increase the saturation and adjust the white balance if the image needs it. This image was exposed for 1/45 second at f/2.8 at ISO 100.

TTL Fill. Photographers shooting 35mm systems often prefer on-camera TTL flash. Many of these systems feature a mode that will adjust the flash output to the ambient-light exposure for balanced fill-flash. Many such systems also offer flash-output compensation that allows you to dial in full- or fractional-stop output changes for the desired ratio of ambient-to-fill illumination. They are marvelous systems and, more importantly, they are reliable and predictable. Some of these systems also allow you to remove the flash from the camera with a TTL remote cord.

Some of the latest digital SLRs and TTL flash systems allow you to set up remote flash units in groups, all keyed to the flash on the camera. You could, for instance, photograph a family group with four synced flashes remotely fired from the camera location, all producing the desired output for the predetermined flash-to-daylight ratio.

Flash-Fill with Studio Strobes. If you are using a studio-type strobe, the flash output can be regulated by adjusting the flash unit's power settings, which are usually fractional—½, ¼, ⅛, and so forth. If, for example, the daylight exposure is 1/60 second at f/8, you could set your flash output so that the flash exposure is f/5.6 or less to create good flash-fill illumination.

Flash Key. You may want to use your flash as a key light that overrides the ambient daylight. When using this technique, it is best if the flash can be removed from the camera and positioned above and to one side of the subject. This will more closely imitate nature's light, which always comes from above and never head-on. Moving the flash to the side will improve the modeling qualities of the light and show more roundness in the face.

When adding flash as the key light, it is important to remember that you are balancing two light sources in one scene. The ambient light exposure will dictate the exposure on the background and the subjects. The flash exposure only affects the subjects. Knowing this, you can use the difference between the ambient and flash exposures to darken the background and enhance the colors in it. However, it is unwise to override the ambient light exposure by more than two f-stops. This will cause a spotlight effect that will make the portrait appear as if it were shot at night.

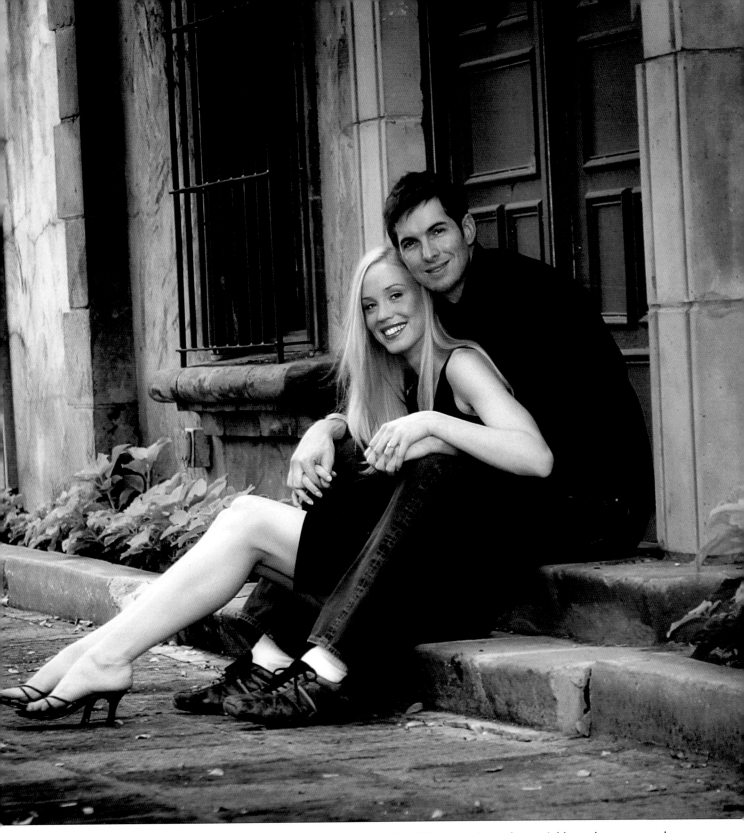

Remember that electronic flash falls off in intensity rather quickly, so be sure to take your meter readings from the center of the subject area (and, with group portraits, from either end—just to be on the safe side). With a small group of three or four people you can get away with moving the strobe away from the camera to get better modeling—but not with larger groups, as the falloff is too great. You can, however, add a second flash of equal intensity and distance on the opposite side of the camera to help widen

the light. If using two light sources, be sure to measure both flashes simultaneously for an accurate reading.

Flash Key with Direct Sun. If you are forced to shoot in direct sunlight (the background or location may be irresistible) position your subject with the sun behind them and use flash to create a frontal lighting pattern. The flash should be set to produce the same exposure as the daylight. The daylight will act like a background light and the flash, set to the same exposure, will act like a key light. Use the flash in a reflector or diffuser of some type to focus the light. If your exposure is $^{1}/_{250}$ second at f/8, for example, your flash would be set to produce an f/8 on the subject. Position the flash to the side of the subject and elevate it for good facial modeling. An assistant or light stand will be called for in this setup. You may want to warm the flash output with a warming gel over the flash reflector. This is when DSLRs are handy.

Flash Key on Overcast Days. When the flash exposure and the daylight exposure are identical, the effect is like creating your own sunlight. This works particularly well on overcast days when using barebulb flash, which is a point-light source like the sun. Position the flash to the right or left of the subject and elevate it for better modeling. If

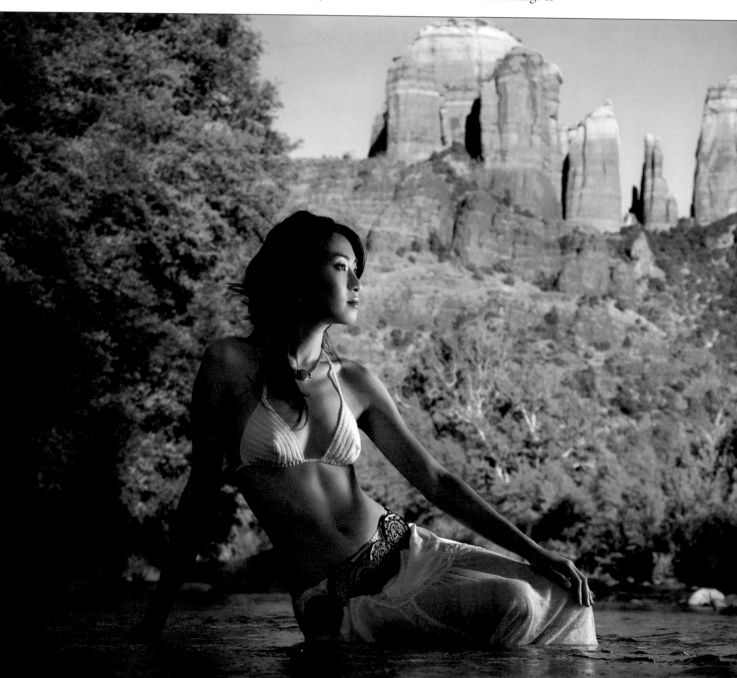

you want to accentuate the lighting pattern and darken the background, increase the flash output to ½ to one stop greater than the daylight exposure and expose for the flash exposure. Do not underexpose your background by more than a stop, however, or you will produce an unnatural nighttime effect. Many times, this technique will allow you to shoot out in open shade without fear of creating shadows that hollow the eye sockets. The overhead nature of the diffused daylight will be overridden by the directional flash, which creates its own lighting pattern. To further refine the look, you can warm up the flash by placing a warming gel over the barebulb flash's clear shield. The gel will warm the facial lighting, but not the rest of the scene. You can also warm the white-balance setting.

Cool Skin Tones

A problem you may encounter is cool coloration in portraits taken in shade. If your subject is standing in a grove of trees surrounded by foliage, there is a good chance green will be reflected into the skin tones. Just as often, the foliage surrounding your subject in shade will reflect the cyan of an open blue sky.

In order to correct green or cyan coloration, you must observe it. Your eyes will become accustomed to seeing the off-color rendering, so you will need to study the faces carefully—especially the coloration of the shadow areas of the face. If the color of the light is neutral, you will see gray in the shadows. If not, you will see either green or cyan.

Before digital capture, if you had to correct this coloration, you would use color-compensating (CC) filters over the lens. These are gelatin filters that fit in a filter holder.

LEFT—Bruce Dorn has come up with a remote softbox that he uses on location called the Strobe Slipper (available from his website: www.idcphotography.com). The Photoflex softbox is small and maneuverable and uses a Canon (or Nikon) speedlight mounted to a stainless steel plate, which also holds a Pocket Wizard receiver. The wireless transmitter is mounted in the hot shoe of Dorn's Canon EOS 20D. The image here was made with a Strobe Slipper with the light used facing the model and allowed to wrap around her with no reflector. The strobe exposure was, naturally, balanced with the daylight exposure for a perfect combination of daylight and strobe. **BELOW**—Strobe Slipper Plus shown with Pocket Wizard receiver mounted on PhotoFlex heavy-duty Swivel with PhotoFlex Adjustable Shoe Mount and Q39 X-small softbox.

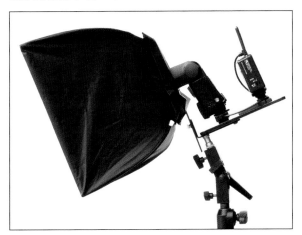

To correct the color shift, you would use the complimentary filter to neutralize the color balance of the light. With digital you only need to perform a custom white balance or use one of the camera's preprogrammed white balance settings, like "open shade." Those who use the ExpoDisc swear by its accuracy in these kinds of situations. By correcting the white balance, there is no need to color-correct the scene with filters.

There are times, however, when you want the light to be warm, not neutral. In these situations, you can use a gold-foil reflector to bounce warm light into the faces. The reflector does not change the color of the foliage or background, just the skin tones.

Conclusion

Light is the essence of great photography. Mastering lighting techniques still takes dedication and study, but the tools now are better than at any time in photography's long history. Portable lighting and camera-controlled, through-the-lens control of multiple flash units is no longer a dream, it's an affordable reality. Professional lighting gear offers an expanding array of devices and modifiers designed to produce incredible effects. Combine these technological advances with digital photography's ease of color balance and great low-light sensitivity and photographers have many more lighting options than ever before. Photographers and their full complement of lighting gear are also much more mobile than ever before, making the world their studio.

"Of course, equipment doesn't make great photographs, great photographers do."

At this writing, new developments in DSLRs have expanded the attainable ISOs exponentially. The Nikon D3, for example, can record flawless, noiseless images at ISO 12,000 and black & white images at an amazing ISO 25,600. In low light, the range of lighting possibilities is expanded, opening up many new avenues of creative exploration.

Of course, equipment doesn't make great photographs, great photographers do. So in order to light like a master, one must be able to see light like a master. Observation and absorption are the keys. Become a student of light. See it in the car or when walking the dog. See it in your kids' eyes or in the fading light coming through the curtains late in the day. Use the new and powerful tools to their full capacity, but don't underestimate the insight of your mind and eye to discover and then incorporate the many nuances of light in the natural world. Be a student of light for life.

Bill Hurter
February, 2008

The Photographers

Barbara Bauer *(PPA Certified, M.Photog.Cr, PFA, ALPE, Hon. ALPE)*. Barbara is a graduate of Rhode Island School of Photography. Her portraits have won numerous awards in regional, national and international competitions.

Marcus Bell. Marcus Bell's creative vision, fluid natural style and sensitivity have made him one of Australia's most revered photographers. It's this talent combined with his natural ability to make people feel at ease in front of the lens that attracts many of his clients. Marcus' work has been published in numerous magazines, including *Black White, Capture, Portfolio Bride,* and countless other bridal magazines.

Don Blair. For fifty years, the name Don Blair was synonymous with fine portraiture, craftsmanship, and extraordinary contributions to the industry. It's no accident that he remains among the most respected of all portrait photographers—and photography instructors. Don was affectionately known to many as "Big Daddy."

Stacy Dail Bratton. Stacy is a studio owner and an accomplished children's and family photographer, having shot more than 2500 baby portraits over the years. She is a graduate of Art Center College of Design in Pasadena, CA.

Joe Buissink. Joe Buissink is an internationally recognized wedding photographer from Beverly Hills, CA. Almost every potential bride who picks up a bridal magazine will have seen Joe Buissink's photography. He has photographed numerous celebrity weddings, including Christina Aguilera's 2005 wedding, and is a multiple Grand Award winner in WPPI print competition.

Drake Busath *(Master Photographer, Craftsman)*. Drake Busath is a second-generation professional photographer who has spoken all over the world and has been featured in a wide variety of professional magazines. Drake also runs a popular photography workshop series in Northern Italy.

Anthony Cava *(BA, MPA, APPO)*. Anthony owns and operates Photolux Studio with his brother, Frank. At thirty years old, he became the youngest Master of Photographic Arts in Canada. Anthony also won WPPI's Grand Award with the first print he ever entered in competition.

Tony Corbell. Tony Corbell is currently director of Technical Services and senior photographer for Hasselblad USA Inc. He is also is the "dean" of Hasselblad's educational efforts, Hasselblad University and founder of the newly created International Wedding Institute. Before joining Hasselblad, Tony was a faculty member and Director of Public Affairs for Brooks Institute of Photography.

Michael Costa. Michael Costa is an award-winning photographer who graduated with honors from the world-renowned Brooks Institute of Photography in Santa Barbara, CA, receiving the coveted Departmental Award in the Still Photography program. He started his successful business with his wife, Anna during his last year at Brooks.

Cherie Steinberg Coté. Cherie Steinberg Coté began her photography career as a photojournalist at the *Toronto Sun,* where she had the distinction of being the first female freelance photographer. She currently lives in Los Angeles and has recently been published in the *L.A. Times, Los Angeles Magazine,* and *Town & Country.*

Bruce Dorn and Maura Dutra. These award-winning digital imagemakers learned their craft in Hollywood, New York, and Paris. Maura has twenty years' experience as an art director and visual effects producer, and Bruce capped a youthful career in fashion and advertising photography with a twenty-year tenure in the very exclusive Director's Guild of America. They have earned a plethora of industry awards for excellence in image-making, and now teach worldwide.

Fuzzy Duenkel (*M.Photog., Cr., CPP*) **and Shirley Duenkel.** Fuzzy has been honored with numerous awards, including four Fuji Masterpiece Awards. In 1996 and 1997, he was named Photographer of the Year for the Southeastern Wisconsin PPA. Fuzzy has had fifteen prints selected for National Traveling Loan Collection, two for Disney's Epcot Center, one for Photokina in Germany, and one for the International Hall of Fame and Museum in Oklahoma.

Deborah Lynn Ferro. A professional photographer since 1996, Deborah calls upon her background as a watercolor artist. She is a popular instructor and the author of *Artistic Techniques with Adobe Photoshop and Corel Painter*, from Amherst Media.

Beth Forester. Beth Forester is owner and operator of Forester Photography in Madison, WV. She is a board member for the Professional Photographers of West Virginia and was named Mid-East States Photographer of the Year in 2006 and in 2007. Beth has also earned numerous Kodak Gallery and Fuji Masterpiece Awards.

Jerry Ghionis. Jerry Ghionis of XSiGHT Photography and Video is one of Australia's leading photographers. In 1999, he was honored with the AIPP (Australian Institute of Professional Photography) award for best new talent in Victoria. In 2002, he won the AIPP's Victorian Wedding Album of the Year; a year later, he won the Grand Award in WPPI's album competition.

Kevin Jairaj. Kevin is a fashion photographer turned wedding and portrait photographer whose creative eye has earned him a stellar reputation in the Dallas/Fort Worth, TX area. His web site is: www.kjimages.com.

Claude Jodoin. Claude Jodoin is an award-winning photographer from Detroit, Michigan. He has been involved in digital imaging since 1986 and has not used film since 1999. He is an event specialist, as well as shooting numerous weddings and portrait sessions throughout the year. You can e-mail him at claudej1@aol.com.

Giorgio Karayiannis. Giorgio Karayiannis is one of those rare photographers who specializes in editorial, fashion, advertising, commercial, and portrait photography—and is successful at each. He has been a technical photographic adviser for the Ilford Imaging Group International, and has won numerous awards from AIPP and WPPI.

Tim Kelly (*M.Photog.*). Tim Kelly is an award-winning photographer and the owner of a studio in Lake Mary, FL. Since 1988, he has developed educational programs and delivered them to professional portrait photographers worldwide. Tim was named Florida's Portrait Photographer of the Year in 2001 and has earned numerous Kodak Awards of Excellence and Gallery Awards.

Craig Kienast. Working in the small-market town of Clear Lake, IA, Kienast ordinarily gets more than double the fees of his nearest competitor (about $1200 for most of his high-school senior orders). Samples of Craig's work and teaching materials can be seen at www.photock.com.

Charles and Jennifer Maring. Charles and Jennifer Maring own Maring Photography Inc. in Wallingford, CT. His parents, also photographers, operate Rlab (resolutionlab.com), a digital lab that does all of the work for Maring Photography and other discriminating photographers. Charles Maring was the winner of WPPI's Album of the Year Award in 2001.

William S. McIntosh (*M.Photog.,Cr., F-ASP*). Bill McIntosh photographs executives and their families all over the U.S. and travels to England frequently on special assignments. He has lectured all over the world and is the author of *Classic Portrait Photography*, from Amherst Media.

Chris Nelson. After graduating from the University of Wisconsin in 1985 with a degree in English and Journalism, Chris worked for six years as a photographer and reporter for the *Milwaukee Sentinel*. In 1991 he opened a studio, where he concentrates on lifestyle portraits with a photojournalistic edge.

Mark Nixon. Mark, who runs The Portrait Studio in Clontarf, Ireland, recently won Ireland's most prestigious photographic award with a panel of four wedding images. He is currently expanding his business to be international in nature and he is on the worldwide lecture circuit.

Larry Peters. Larry is one of the most successful and award-winning senior-portrait photographers in the nation. His popular web site is loaded with good information about photographing seniors: www.petersphotography.com

Greg Phelps. An award winning photographer, Gregory James Phelps has been bringing his vision and skill to images created for Fortune 500 comapnies for 25 years. His portrait commissions have included astronauts, CEOs, congressmen, and numberous other dignataries. He can be reached at: greg@gjphelps.com.

Fran Reisner. Fran is an award-winning photographer from Frisco, TX. She is a Brooks Institute graduate and has been twice named Dallas Photographer of the Year. She is also a past president of the Dallas Professional Photographers Association.

Tero Sade. Tero Sade is one of Australia's leading portrait photographers. In 2003, Tero sold his successful Brisbane business to return to Tasmania, where he donates every sitting fee to Make a Wish foundation. To see more of Tero's work, visit www.tero.com.au.

Tim Schooler. Tim is an award-winning photographer specializing in high-school senior portraits with a cutting edge. Tim's work has been published internationally in magazines and books. His studio is located in Lafayette, LA. Visit his website: www.timschooler.com.

Brian and Judith Shindle. Brian and Judith Shindle own and operate Creative Moments in Westerville, OH. This studio is home to three enterprises under one umbrella: a working photography studio, an art gallery, and a full-blown event-planning business. Brian's work has received numerous awards from WPPI in international competition.

E. J. Simpson. E. J. Simpson holds an MA in Photography and Photojournalism from San Jose State University and taught ohotography at Chabot College in California. His images have been published by *Rangefinder* magazine, the National Parks Service, the *Pro Rodeo Sports* magazine, the Yosemite Association and have won accolades of excellence in WPPI's international print competition.

Kenneth Sklute. Kenneth began his career in Long Island, and now operates a thriving studio in Arizona. He has been named Long Island Wedding Photographer of The Year (fourteen times!), PPA Photographer of the Year, and APPA Wedding Photographer of the Year. He has also earned numerous Fuji Masterpiece Awards and Kodak Gallery Awards.

Jeff Smith. Jeff is an award-winning portrait photographer who owns two studios in Central California. He is well recognized as a speaker, and the author of *Corrective Lighting, Posing, and Retouching Techniques*, from Amherst Media. He can be reached at: www.jeffsmithphoto.com.

Vicki and Jed Taufer. Vicki and Jed are the owners of V Gallery, a prestigious portrait studio in Morton, IL. Vicki has received national recognition for her portraits, and is an award winner in WPPI print competitions. Jed is the head of the imaging department at V Gallery.

Johannes Van Kan and Jo Gram. Johannes and Jo are the principals at Christchurch, New Zealand's Flax Studios, which caters to high-end wedding clients. Johannes has a background in newspaper photography and worked for Ric Syme, a well known wedding photographer from Perth, Australia, where he learned the wedding craft. Jo learned her skills by assisting Vanessa Hall in Melbourne and Marcus Bell in Brisbane, Australia. In 2005 Jo and Johannes teamed up and have been winning major awards in both Australia and New Zealand ever since.

Marc Weisberg. Marc Weisberg specializes in wedding and event photography. A graduate of UC Irvine with a degree in fine art and photography, he also attended the School of Visual Arts in New York City before relocating to Southern California in 1991. His images have been featured in *Wines and Spirits*, *Riviera*, *Orange Coast Magazine*, and *Where Los Angeles*.

Jeffrey and Julia Woods. Jeffrey and Julia Woods are award-winning wedding and portrait photographers who work as a team. They were awarded WPPI's Best Wedding Album of the Year for 2002 and 2003, two Fuji Masterpiece awards, and a Kodak Gallery Award. See more of their images at www.jwweddinglife.com.

Reed Young. Reed is a graduate of Brooks Institute who has focused his interests on fashion photography. Although he grew up in Minnesota, he is currently working out of New York. More of his work can be seen at www.reedyoung.com.

Yervant Zanazanian *(M. Photog. AIPP, F.AIPP)*. Yervant was born in Ethiopia (East Africa), where he worked after school at his father's photography business (his father was photographer to the Emperor Hailé Silassé of Ethiopia). Yervant owns one of the most prestigious photography studios of Australia and services clients both nationally and internationally.

Glossary

Barn doors. Black, metal folding doors that attach to a light's reflector. Used to control the width of the beam of light.

Bounce flash. Bouncing the light of a studio or portable flash off a surface such as a ceiling or wall to produce indirect, shadowless lighting.

Box light. A diffused light source housed in a box-shaped reflector. The front of the box is translucent material; the side pieces of the box are opaque, but they are coated with a reflective material such as foil on the inside to optimize light output.

Broad lighting. One of two basic types of portrait lighting. In broad lighting, the key light illuminates the side of the subject's face turned toward the camera.

Butterfly lighting. One of the basic portrait lighting patterns, characterized by a key light placed high and directly in line with the line of the subject's nose. This lighting produces a butterfly-like shadow under the nose. Also called Paramount lighting.

Catchlight. The specular highlights that appear in the iris or pupil of the subject's eyes. These are reflections from the portrait lights.

Color temperature. The degrees Kelvin of a light source or film sensitivity. Color films are balanced for 5500K (daylight), 3200K (tungsten), or 3400K (photoflood).

Cross-lighting. Lighting that comes from the side of the subject, skimming across the facial surfaces to reveal the maximum texture in the skin. Also called side-lighting.

Depth of field. The distance that is sharp beyond and in front of the focus point at a given f-stop.

Depth of focus. The amount of sharpness that extends in front of and behind the focus point. Some lenses' depth of focus extends 50 percent in front of and 50 percent behind the focus point. Other lenses vary.

Diffusion flat. A portable, translucent diffuser that can be positioned in a window frame or near the subject to diffuse the light striking the subject.

Dragging the shutter. Using a shutter speed slower than the X-sync speed in order to capture the ambient light in a scene.

Fashion lighting. A shadowless type of lighting that is created by placing the main light on the lens axis. Fashion lighting is usually very soft in quality.

Feathering. Misdirecting the light deliberately so that the edge of the beam of light illuminates the subject.

Fill card. A white or silver foil–covered card used to reflect light back into the shadow areas of the subject.

Fill light. A secondary light source used to illuminate the shadows created by the key light.

Flash fill. A flash technique that uses electronic flash to fill in the shadows created by the main light source.

Flash key. A technique in which the flash becomes the main light source and the ambient light in the scene fills the shadows created by the flash.

Flashmeter. A handheld incident light meter that measures both the ambient light of a scene and, when connected to an electronic flash, will read flash only or a combination of flash and ambient light. This is invaluable for determining outdoor flash exposures and lighting ratios.

45-degree lighting. A portrait lighting pattern that is characterized by a triangular highlight on the shadow side of the face. Also known as Rembrandt lighting.

Gaussian blur. Photoshop filter that diffuses a digital image.

Gobo. A light-blocking card that is positioned between the light source and subject to selectively block light from portions of the scene.

High-key lighting. A type of lighting characterized by a low lighting ratio and a predominance of light tones.

Highlight brilliance. Refers to the specularity of highlights on the skin. A negative with good highlight brilliance shows specular highlights (paper base white) within a major highlight area. This is achieved through good lighting and exposure techniques.

Histogram. A graphic representation (unique for each image) that indicates the number of pixels that exist for each brightness level. The range of the histogram extends from "absolute" black (on the left) to "absolute" white (on the right).

Hot spot. A highlight area of the negative that is overexposed and without detail. In film photography, these areas can sometimes be etched down to a printable density.

Incident light meter. A handheld light meter that measures the amount of light falling on its light-sensitive dome.

Key light. The main light in portraiture used to establish the lighting pattern and define the facial features of the subject.

Kicker. A light coming from behind the subject that highlights the hair or contour of the body.

Lighting ratio. The difference in intensity between the highlight side of the face and the shadow side of the face. A 3:1 ratio implies that the highlight side is three times brighter than the shadow side of the face.

Loop lighting. A portrait lighting pattern characterized by a loop-like shadow on the shadow side of the subject's face. This differs from Paramount or butterfly lighting because the main light is slightly lower and farther to the side of the subject.

Low-key lighting. A type of lighting characterized by a high lighting ratio and strong scene contrast as well as a predominance of dark tones.

Main light. Synonymous with key light.

Modeling light. A secondary light mounted in the center of a studio flash head that gives a close approximation of the lighting that the flash tube will produce. Usually, modeling lights employ high intensity, low heat-output quartz bulbs.

Overlighting. Condition that occurs when the main light is too close to the subject or too intense. This excessive light makes it impossible to record detail in highlighted areas. This is best corrected by feathering the light or moving it back from the subject.

Parabolic reflector. An oval-shaped dish that houses a light and directs its beam outward in an even and controlled manner.

Paramount lighting. One of the basic portrait lighting patterns, Paramount lighting is characterized by a key light placed high and directly in line with the subject's nose. This lighting produces a butterfly-like shadow under the nose. Also called butterfly lighting.

Point light source. A small light source, like the sun, which produces sharp-edged shadows without diffusion.

RAW file. A file format that records the picture data from a digital sensor without applying any in-camera corrections. In order to use images recorded in the RAW format, the files must first be processed by compatible software. RAW processing includes the option to adjust exposure, white balance, and color of the image, all the while leaving the original RAW picture data unchanged.

Reflected light meter. A meter that measures the amount of light reflected from a surface or scene. All in-camera meters are of the reflected type.

Reflector. (1) Same as fill card. (2) A housing on a light that reflects the light outward in a controlled beam.

Rembrandt lighting. Same as 45-degree lighting.

Rim lighting. Portrait lighting pattern where the key light is placed behind the subject and illuminates the edge of the subject. This is most often used with profile poses.

Scrim. A panel used to diffuse sunlight. Scrims can be mounted in panels and set in windows, used on stands, or they can be suspended in front of a light source to diffuse the light.

Sharpening. In Photoshop, filters that increase apparent sharpness of an image by increasing the contrast of adjacent pixels within it.

Short lighting. One of two basic types of portrait lighting. In short lighting, the key light illuminates the side of the face turned away from the camera.

Slave. A remote triggering device used to fire auxiliary flash units. These may be optical or radio-controlled.

Softbox. Same as a box light. It can contain one or more light heads and employ either a single or double-diffused scrim.

Specular highlights. Very small, bright, paper-base white highlights.

Split lighting. A type of portrait lighting that splits the face into two distinct areas: a shadow side and a highlight side. The key light is placed far to the side of the subject and slightly higher than the subject's head height.

Straight flash. The light of an on-camera flash unit that is used without diffusion.

Subtractive fill-in. Lighting technique that uses a black card to subtract light out of a subject area in order to create a better defined lighting ratio. Also refers to the placement of a black card over the subject in outdoor portraiture to make the light more frontal and less overhead.

TTL-balanced fill flash. A flash exposure system that reads the flash exposure through the camera lens and adjusts the flash output relative to the ambient light for a balanced flash–ambient exposure.

Umbrella. A type of light modifier used to diffuse a light source.

Unsharp mask. A sharpening tool in Adobe Photoshop that is usually the last step in preparing an image for printing.

Watt-seconds (Ws). Numerical system used to rate the power output of electronic flash units. This is primarily used to rate studio strobe systems.

Wraparound lighting. A soft type of light that wraps around subjects to produce a low lighting ratio and open, well-illuminated highlight areas.

Index

PORTRAIT PHOTOGRAPHER'S HANDBOOK, 3rd Ed.

Bill Hurter

A step-by-step guide that easily leads the reader through all phases of portrait photography. This book will be an asset to experienced photographers and beginners alike. $34.95 list, 8.5x11, 128p, 175 color photos, order no. 1844.

THE BEST OF CHILDREN'S PORTRAIT PHOTOGRAPHY

Bill Hurter

Rangefinder editor Bill Hurter draws upon the experience and work of top professional photographers, uncovering the creative and technical skills they use to create their magical portraits of these young subjects. $29.95 list, 8.5x11, 128p, 150 color photos, order no. 1752.

THE BEST OF FAMILY PORTRAIT PHOTOGRAPHY

Bill Hurter

Acclaimed photographers reveal the secrets behind their most successful family portraits. Packed with award-winning images and helpful techniques. $34.95 list, 8.5x11, 128p, 150 color photos, index, order no. 1812.

THE PORTRAIT PHOTOGRAPHER'S GUIDE TO POSING

Bill Hurter

Posing can make or break an image. Now you can get the posing tips and techniques that have propelled the finest portrait photographers in the industry to the top. $34.95 list, 8.5x11, 128p, 200 color photos, index, order no. 1779.

THE BEST OF TEEN AND SENIOR PORTRAIT PHOTOGRAPHY

Bill Hurter

Learn how top professionals create stunning images that capture the personality of their teen and senior subjects. $34.95 list, 8.5x11, 128p, 150 color photos, index, order no. 1766.

THE BEST OF WEDDING PHOTOJOURNALISM

Bill Hurter

Learn how top professionals capture these fleeting moments of laughter, tears, and romance. Features images from over twenty renowned wedding photographers. $34.95 list, 8.5x11, 128p, 150 color photos, index, order no. 1774.

WEDDING PHOTOGRAPHER'S HANDBOOK

Bill Hurter

Learn to produce images with technical proficiency and superb, unbridled artistry. Includes images and insights from top industry pros. $34.95 list, 8.5x11, 128p, 180 color photos, 10 screen shots, index, order no. 1827.

RANGEFINDER'S PROFESSIONAL PHOTOGRAPHY

edited by Bill Hurter

Editor Bill Hurter shares over one hundred "recipes" from *Rangefinder's* popular cookbook series, showing you how to shoot, pose, light, and edit fabulous images. $34.95 list, 8.5x11, 128p, 150 color photos, index, order no. 1828.

GROUP PORTRAIT PHOTOGRAPHY HANDBOOK
2nd Ed.

Bill Hurter

Featuring over 100 images by top photographers, this book offers practical techniques for composing, lighting, and posing group portraits—whether in the studio or on location. $34.95 list, 8.5x11, 128p, 120 color photos, order no. 1740.

THE BEST OF WEDDING PHOTOGRAPHY, 3rd Ed.

Bill Hurter

Learn how the top wedding photographers in the industry transform special moments into lasting romantic treasures with the posing, lighting, album design, and customer service pointers found in this book. $34.95 list, 8.5x11, 128p, 200 color photos, order no. 1837.

THE BEST OF
ADOBE® PHOTOSHOP®

Bill Hurter

Rangefinder editor Bill Hurter calls on the industry's top photographers to share their strategies for using Photoshop to intensify and sculpt their images. $34.95 list, 8.5x11, 128p, 170 color photos, 10 screen shots, index, order no. 1818.

CHILDREN'S PORTRAIT
PHOTOGRAPHY HANDBOOK

Bill Hurter

Packed with inside tips from industry leaders, this book shows you the ins and outs of working with some of photography's most challenging subjects. $34.95 list, 8.5x11, 128p, 175 color images, index, order no. 1840.

MASTER LIGHTING GUIDE
FOR WEDDING PHOTOGRAPHERS

Bill Hurter

Capture perfect lighting quickly and easily at the ceremony and reception—indoors and out. Includes tips from the pros for lighting individuals, couples, and groups. $34.95 list, 8.5x11, 128p, 200 color photos, index, order no. 1852.

SUCCESS IN
PORTRAIT PHOTOGRAPHY

Jeff Smith

Many photographers realize too late that camera skills alone do not ensure success. This book will teach photographers how to run savvy marketing campaigns, attract clients, and provide top-notch customer service. $29.95 list, 8.5x11, 128p, 100 color photos, order no. 1748.

CORRECTIVE LIGHTING,
POSING & RETOUCHING FOR
DIGITAL PORTRAIT PHOTOGRAPHERS, 2nd Ed.

Jeff Smith

Learn to make every client look his or her best by using lighting and posing to conceal real or imagined flaws—from baldness, to acne, to figure flaws. $34.95 list, 8.5x11, 120p, 150 color photos, order no. 1711.

WEDDING PHOTOGRAPHY
CREATIVE TECHNIQUES FOR LIGHTING, POSING, AND MARKETING, 3rd Ed.

Rick Ferro

Creative techniques for lighting and posing wedding portraits that will set your work apart from the competition. Covers every phase of wedding photography. $34.95 list, 8.5x11, 128p, 125 color photos, index, order no. 1649.

PROFESSIONAL TECHNIQUES FOR
DIGITAL WEDDING
PHOTOGRAPHY, 2nd Ed.

Jeff Hawkins and Kathleen Hawkins

From selecting equipment, to marketing, to building a digital workflow, this book teaches how to make digital work for you. $34.95 list, 8.5x11, 128p, 85 color images, order no. 1735.

LIGHTING TECHNIQUES FOR
HIGH KEY PORTRAIT
PHOTOGRAPHY

Norman Phillips

Learn to meet the challenges of high key portrait photography and produce images your clients will adore. $34.95 list, 8.5x11, 128p, 100 color photos, order no. 1736.

LIGHTING TECHNIQUES FOR
LOW KEY PORTRAIT
PHOTOGRAPHY

Norman Phillips

Learn to create the dark tones and dramatic lighting that typify this classic portrait style. $34.95 list, 8.5x11, 128p, 100 color photos, index, order no. 1773.

THE PORTRAIT BOOK
A GUIDE FOR PHOTOGRAPHERS

Steven H. Begleiter

A comprehensive textbook for those getting started in professional portrait photography. Covers every aspect from designing an image to executing the shoot. $29.95 list, 8.5x11, 128p, 130 color images, index, order no. 1767.

BEGINNER'S GUIDE TO
PHOTOGRAPHIC LIGHTING

Don Marr

Create high-impact photographs of any subject with Marr's simple techniques. From edgy and dynamic to subdued and natural, this book will show you how to get the myriad effects you're after. $34.95 list, 8.5x11, 128p, 150 color photos, index, order no. 1785.

POSING FOR PORTRAIT
PHOTOGRAPHY
A HEAD-TO-TOE GUIDE

Jeff Smith

Author Jeff Smith teaches surefire techniques for fine-tuning every aspect of the pose for the most flattering results. $34.95 list, 8.5x11, 128p, 150 color photos, index, order no. 1786.

PROFESSIONAL MODEL PORTFOLIOS
A STEP-BY-STEP GUIDE FOR PHOTOGRAPHERS

Billy Pegram

Learn to create portfolios that will get your clients noticed—and hired! $34.95 list, 8.5x11, 128p, 100 color images, index, order no. 1789.

MASTER LIGHTING GUIDE
FOR PORTRAIT PHOTOGRAPHERS

Christopher Grey

Efficiently light executive and model portraits, high and low key images, and more. Master traditional lighting styles and use creative modi-fications that will maximize your results. $29.95 list, 8.5x11, 128p, 300 color photos, index, order no. 1778.

LIGHTING TECHNIQUES FOR FASHION AND GLAMOUR PHOTOGRAPHY

Stephen A. Dantzig, PsyD.

In fashion and glamour photography, light is the key to producing images with impact. With these techniques, you'll be primed for success! $29.95 list, 8.5x11, 128p, over 200 color images, index, order no. 1795.

WEDDING AND PORTRAIT PHOTOGRAPHERS' LEGAL HANDBOOK

N. Phillips and C. Nudo, Esq.

Don't leave yourself exposed! Sample forms and practical discussions help you protect yourself and your business. $29.95 list, 8.5x11, 128p, 25 sample forms, index, order no. 1796.

MASTER LIGHTING TECHNIQUES
FOR OUTDOOR AND LOCATION DIGITAL PORTRAIT PHOTOGRAPHY

Stephen A. Dantzig

Use natural light alone or with flash fill, barebulb, and strobes to shoot perfect portraits all day long. $34.95 list, 8.5x11, 128p, 175 color photos, diagrams, index, order no. 1821.

PROFITABLE PORTRAITS
THE PHOTOGRAPHER'S GUIDE TO CREATING PORTRAITS THAT SELL

Jeff Smith

Learn how to design images that are precisely tailored to your clients' tastes—portraits that will practically sell themselves! $29.95 list, 8.5x11, 128p, 100 color photos, index, order no. 1797.

MARKETING & SELLING TECHNIQUES
FOR DIGITAL PORTRAIT PHOTOGRAPHY

Kathleen Hawkins

Great portraits aren't enough to ensure the success of your business! Learn how to attract clients and boost your sales. $34.95 list, 8.5x11, 128p, 150 color photos, index, order no. 1804.

PROFESSIONAL MARKETING & SELLING TECHNIQUES FOR
DIGITAL WEDDING PHOTOGRAPHERS
2nd Ed.

Jeff Hawkins and Kathleen Hawkins

Taking great photos isn't enough to ensure success! Become a master marketer and salesperson with these easy techniques. $34.95 list, 8.5x11, 128p, 150 color photos, index, order no. 1815.

ARTISTIC TECHNIQUES WITH ADOBE® PHOTOSHOP® AND COREL® PAINTER®

Deborah Lynn Ferro

Flex your creativity and learn how to transform photographs into fine-art masterpieces. Step-by-step techniques make it easy! $34.95 list, 8.5x11, 128p, 200 color images, index, order no. 1806.

DIGITAL PHOTOGRAPHY BOOT CAMP

Kevin Kubota

Kevin Kubota's popular workshop is now a book! A down-and-dirty, step-by-step course in building a professional photography workflow and creating digital images that sell! $34.95 list, 8.5x11, 128p, 250 color images, index, order no. 1809.

PROFESSIONAL POSING TECHNIQUES FOR WEDDING AND
PORTRAIT PHOTOGRAPHERS

Norman Phillips

Master the techniques you need to pose subjects successfully—whether you are working with men, women, children, or groups. $34.95 list, 8.5x11, 128p, 260 color photos, index, order no. 1810.

DIGITAL CAPTURE AND WORKFLOW
FOR PROFESSIONAL PHOTOGRAPHERS

Tom Lee

Cut your image-processing time by fine-tuning your workflow. Includes tips for working with Photoshop and Adobe Bridge, plus framing, matting, and more. $34.95 list, 8.5x11, 128p, 150 color images, index, order no. 1835.

THE PHOTOGRAPHER'S GUIDE TO
COLOR MANAGEMENT
PROFESSIONAL TECHNIQUES FOR CONSISTENT RESULTS

Phil Nelson

Learn how to keep color consistent from device to device, ensuring greater efficiency and more accurate results. $34.95 list, 8.5x11, 128p, 175 color photos, index, order no. 1838.

MASTER'S GUIDE TO WEDDING PHOTOGRAPHY
CAPTURING UNFORGETTABLE MOMENTS AND LASTING IMPRESSIONS

Marcus Bell

Learn to capture the unique energy and mood of each wedding and build a lifelong client relationship. $34.95 list, 8.5x11, 128p, 200 color photos, index, order no. 1832.

PROFESSIONAL CHILDREN'S PORTRAIT PHOTOGRAPHY

Lou Jacobs Jr.

Fifteen top photographers reveal their most successful techniques—from working with uncooperative kids, to lighting, to marketing your studio. $34.95 list, 8.5x11, 128p, 200 color photos, index, order no. 2001.

JEFF SMITH'S LIGHTING FOR OUTDOOR AND LOCATION PORTRAIT PHOTOGRAPHY

Learn how to use light throughout the day—indoors and out—and make location portraits a highly profitable venture for your studio. $34.95 list, 8.5x11, 128p, 170 color images, index, order no. 1841.

ROLANDO GOMEZ'S
GLAMOUR PHOTOGRAPHY
PROFESSIONAL TECHNIQUES AND IMAGES

Learn how to create classy glamour portraits your clients will adore. Rolando Gomez takes you behind the scenes, offering invaluable technical and professional insights. $34.95 list, 8.5x11, 128p, 150 color images, index, order no. 1842.

MASTER GUIDE FOR GLAMOUR PHOTOGRAPHY

Chris Nelson

Establish a rapport with your model, ensure a successful shoot, and master the essential digital fixes your clients demand. Includes lingerie, semi-nude, and nude images. $34.95 list, 8.5x11, 128p, 200 color photos, index, order no. 1836.

POSING TECHNIQUES FOR PHOTOGRAPHING MODEL PORTFOLIOS

Billy Pegram

Learn to evaluate your model and create flattering poses for fashion photos, catalog and editorial images, and more. $34.95 list, 8.5x11, 128p, 200 color images, index, order no. 1848.

ILLUSTRATED DICTIONARY OF PHOTOGRAPHY

Barbara A. Lynch-Johnt & Michelle Perkins

Gain insight into camera and lighting equipment, accessories, technological advances, film and historic processes, famous photographers, artistic movements, and more with the concise descriptions in this illustrated book. $34.95 list, 8.5x11, 144p, 150 color images, index, order no. 1857.

JEFF SMITH'S POSING TECHNIQUES FOR LOCATION PORTRAIT PHOTOGRAPHY

Use architectural and natural elements to support the pose, maximize the flow of the session, and create refined, artful poses for individual subjects and groups—indoors or out. $34.95 list, 8.5x11, 128p, 150 color photos, index, order no. 1851.